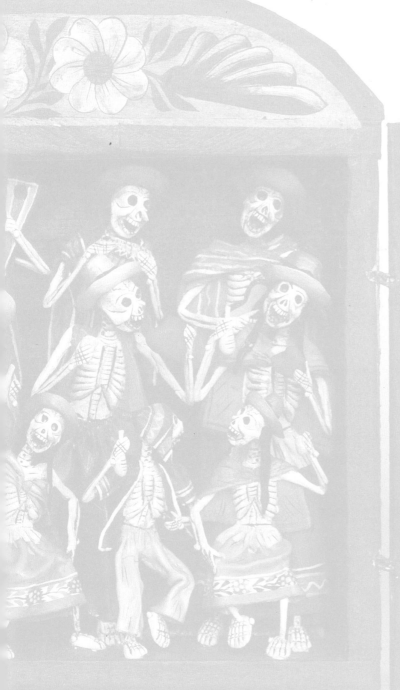

September 2015

Marcia -
 Happy Birthday. Not
many people I know would
even know what 'Day of the Dead'
is. You not only know but made
that the theme of a lovely luncheon.
always so creative.
 xox Joy.

DAY OF THE DEAD
FOLK ART

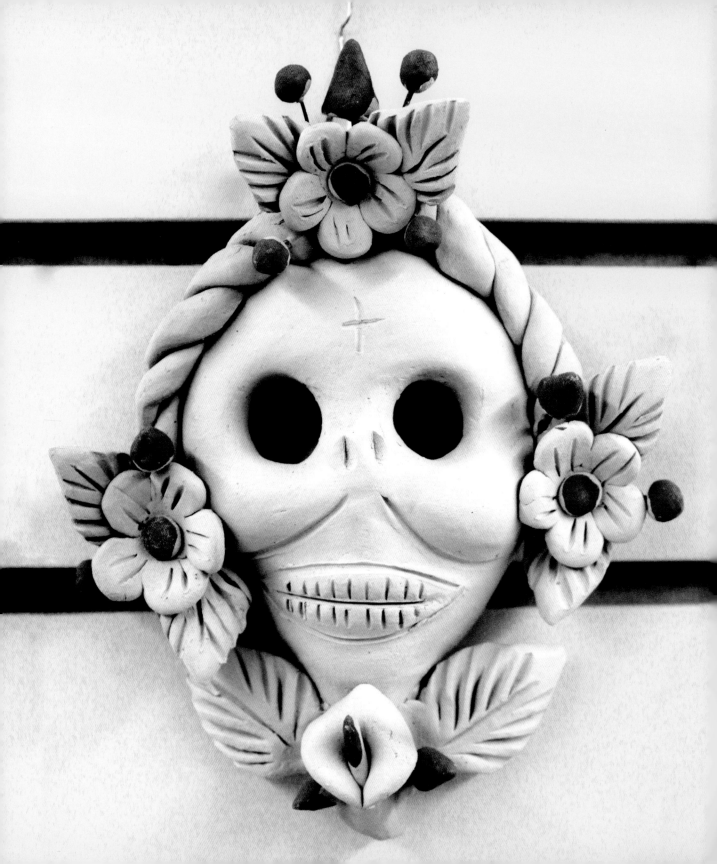

Day of the Dead Folk Art

Stevie Mack

Kitty Williams

GIBBS SMITH
TO ENRICH AND INSPIRE HUMANKIND

To Mike, Chelsea, Scott, and Aubrey,
with much love. —SM

To my parents, Pat and Ed, who
have been there through it all. —KW

First Edition
19 18 17 16 15 5 4 3 2 1

Published by
Gibbs Smith
P.O. Box 667
Layton, Utah 84041

1.800.835.4993 orders
www.gibbs-smith.com

Designed by Kurt Wahlner
Printed and bound in Hong Kong

Gibbs Smith books are printed on either recycled, 100%
post-consumer waste, FSC-certified papers or on paper
produced from sustainable PEFC-certified forest/controlled
wood source. Learn more at www.pefc.org.

Library of Congress Cataloging-in-Publication Data

Mack, Stevie.
 Day of the Dead Folk Art / Stevie Mack and Kitty Williams.
— First Edition.
 pages cm
 ISBN 978-1-4236-3443-0
1. All Souls' Day in art. 2. Folk art—Mexico. 3. Folk art—
Southwest, New. I. Williams, Kitty, 1958- II. Title.
 NK1653.M6M33 2015
 745.0972—dc23
 2015004971

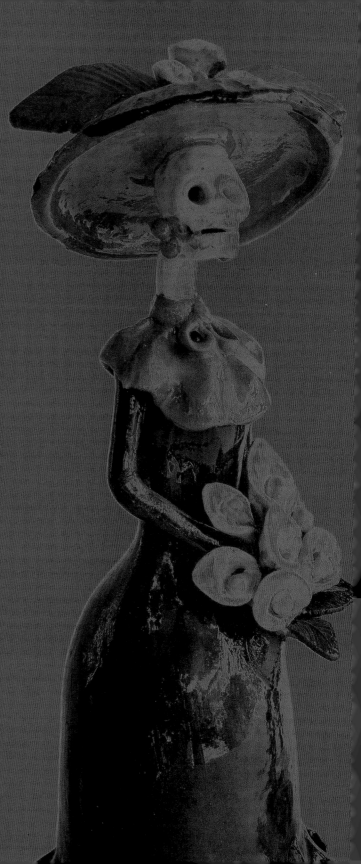

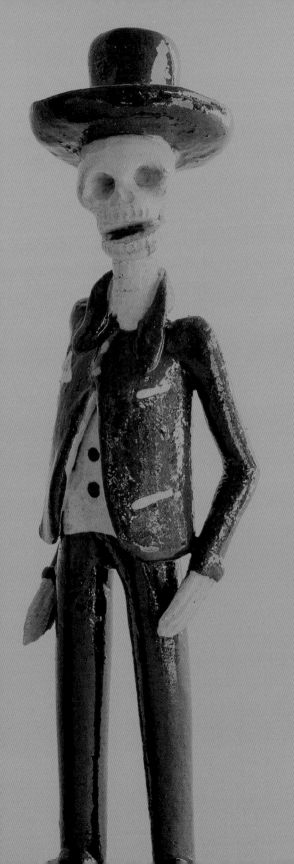

CONTENTS

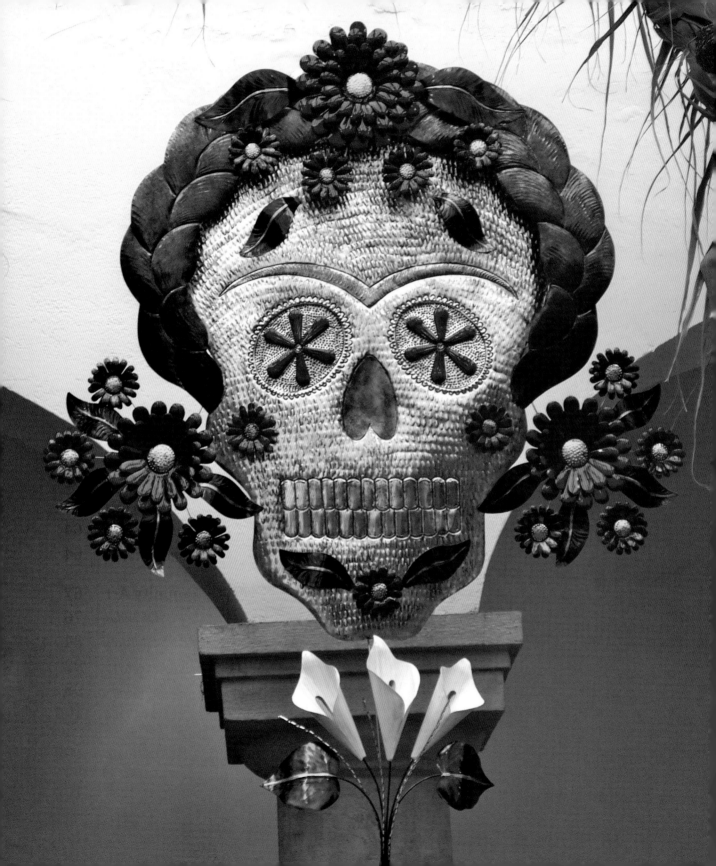

ACKNOWLEDGMENTS

Many people have contributed generously to this book, sharing their advice, support, and enthusiasm. First and foremost, we are grateful to the many artisans who created the fabulous folk art featured in this title. This book is a celebration of their vision and talent.

We would like to thank Gibbs Smith for giving us the opportunity to work with his highly professional staff on this project. Our editor, Bob Cooper, gave us incredible guidance and support from the beginning to the end. His enthusiasm for the topic was encouraging throughout the process.

We are very grateful to the owners of two folk art galleries in California who welcomed us to their establishments, and gave us access and permission to photograph their collections. These galleries represent many of the finest folk artists exhibiting today. Rocky Behr and her staff at the renowned Folk Tree in Pasadena gave us a warm welcome and were available to assist in every way possible. Elexia de la Parra from Casa Artelexia in San Diego provided us with a comfortable space to photograph and offered us access to their collection. Her generosity was critical to the success of this project.

A heartfelt thank you is due to Mike Grassinger, whose steadfast support was invaluable. He offered assistance whenever and wherever it was needed, providing transportation, sustenance, lighting and set design, and general schlepping. His patience and support made this publication possible.

A special thanks to friends and colleagues Nancy Walkup, Bill Yarborough, Colistia and Tom Sawyer, Betty Rowe, and Pat Manion, who gave us advice, encouragement, and permission to photograph their private collections. We would like to extend our deep appreciation to Barbara Cavett at CRIZMAC, who was willing to take the reins and run the store and care for our customers while we traveled and photographed.

And finally, we are grateful to Mary Jane McKitis for her vision and tenacity in making this project a reality.

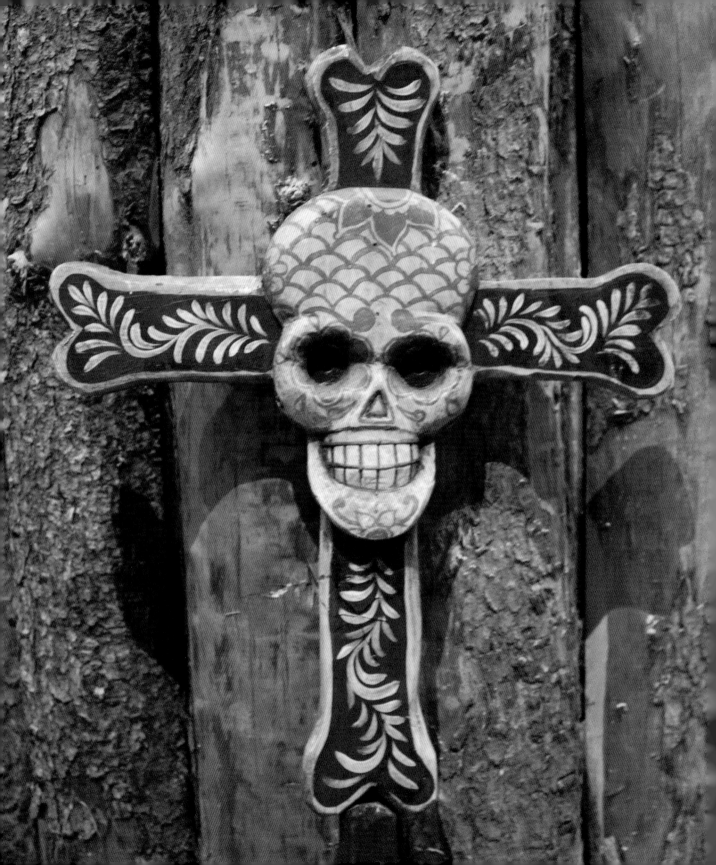

INTRODUCTION

"The art of the craftsman is a bond between the peoples of the world."
—Florence Dibell Bartlett
Founder of the Museum of International Folk Art in Santa Fe, New Mexico

A long row of wooden skeletons hangs in a shop window, their lanky bones dancing a clickety-clacking jig in the breeze. From a building overlooking the street, a tall, elegant skeleton in a wide-brimmed hat and feather boa waves to passers-by. Grinning skulls, ranging in size from miniature to larger-than-life, seem to be everywhere—in the markets; on home altars, or *ofrendas*; in shops, hotels, and other businesses; and adorning the graves in the cemeteries. Made of nearly every material imaginable, from sugar and papier-mâché to amaranth seed, the skulls' whimsical expressions and colorful features create a cheerful rather than morbid mood. Although the preponderance of death imagery may be initially disconcerting to those unfamiliar with the Day of the Dead celebration, the skulls and skeletons are intended to be humorous and are created in recognition of the fleeting nature of life. The holiday has inspired a wide variety of art, in keeping with Mexico's rich folk art tradition.

In the 1500s, when Hernán Cortés arrived in present-day Mexico, he described the Aztec capital and its market of textiles, feathers, gourds, and precious metals. Because the Aztecs had conquered many of the neighboring tribes, they were able to adopt many of their skills and techniques for making a range of crafts.

Following the Spanish conquest, some indigenous crafts were lost, but others emerged, and often represented a synthesis or mingling of the two cultures. The Catholic Church also provided a rich source of imagery. In this way, the Spanish conquest changed the artistic, as well as the spiritual, traditions of the people of Latin America.

Crafts remain an essential part of life in Mexico. While the country has given the world such well-known and well-respected fine artists as Diego Rivera and Frida Kahlo, the art and cultural traditions of many indigenous groups continue to thrive. The folk art they produce identifies them as a people, and serves as a source of pride for their communities. From raw materials as varied as the terrain and geography, a great deal of wonderful art is produced by artists who sell their works from home studios or at local markets and small shops. In the past, most indigenous artists were known only by members of their own communities and a few outside collectors, and consequently did not enjoy widespread recognition.

An early collector of world folk art and the founder of the Museum of International Folk Art in Santa Fe, New Mexico, Florence Dibell Bartlett believed that an appreciation of folk art was one path to international understanding. Certainly, the traditional arts and crafts produced by native peoples around the world reflect many aspects of their cultures, and thus offer outsiders a window into the values and traditions of the people.

Regardless of where it is produced or by whom, most traditional art forms share a number of characteristics. Folk art is generally produced using simple technology from local materials that are readily available. The traditions are passed down from generation to generation, and as a result the art often expresses village or cultural identity through themes that are derived from the daily lives of the artists. For

many artisans in Mexico and elsewhere, their art is the means by which they provide economic support for their families, and it enables them to continue to live traditional lifestyles. Another common characteristic of folk art, which is particularly evident in the Day of the Dead celebration, is that it frequently originated for functional or ceremonial purposes.

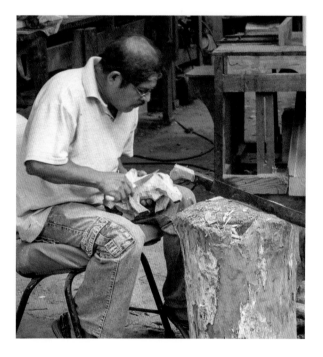

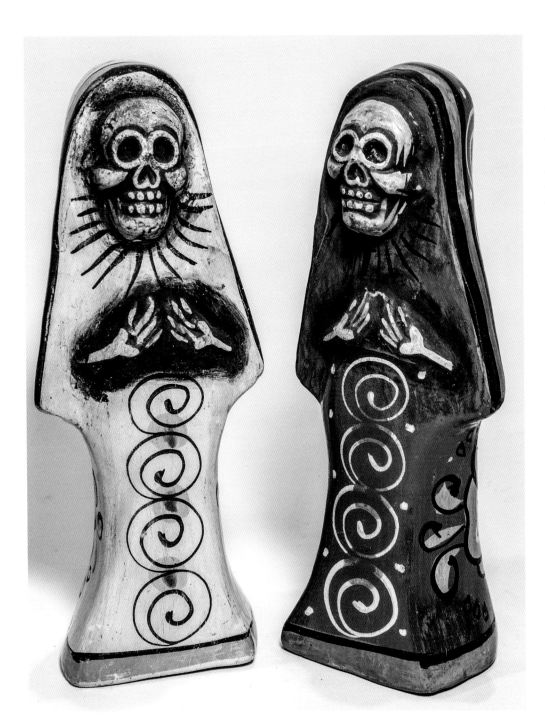

FACING: Woodcarver Agustín Cruz Tinoco, from San Agustín de las Juntas, Oaxaca, Mexico, uses a machete and a knife to carve his figures by hand (top). In many families the women use acrylic paint (bottom) to decorate the woodcarvings created by a spouse or other family member.

LEFT: Simple clay forms depict two nuns wearing religious habits. The skeletal faces and hands are highly expressive. Repeating swirls embellish the fronts of the figures with decoration.

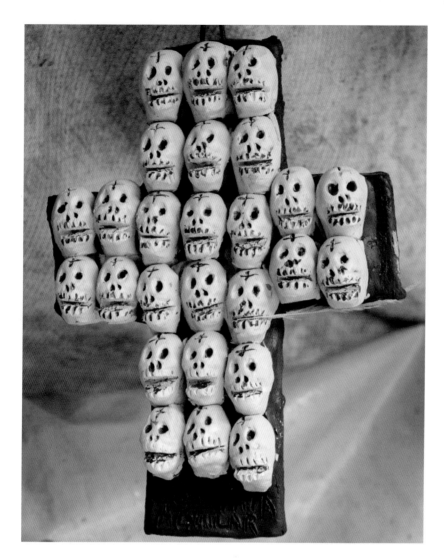

LEFT: *A cross, fashioned with repeating clay skulls, depicts the cultural synthesis between the religious beliefs of preconquest Mexico and Christianity. It was made by a member of the Josefina Aguilar family from Ocotlán de Morelos, Oaxaca.*

FACING: *Many families build* ofrendas *in their homes to honor and welcome their deceased loved ones. This simple yet elegant ofrenda was in the home of the well-known clay artist Magdalena Pedro Martínez from the village of San Bartolo Coyotepec, Oaxaca.*

Through the efforts of Bartlett and other prominent collectors, folk art has emerged as a valued commodity. In the modern world, museums showcase folk art, galleries clamor to represent the "best" artists, and many people collect and decorate their homes with folk art.

The folk art inspired by the Day of the Dead powerfully communicates the cultural traditions and basic meaning of this vibrant holiday. As celebrated today, the Day of the Dead festivities represent a synthesis of Spanish Catholicism and pre-Hispanic beliefs and practices. Over time, the Catholic feasts of All Saints' Day and All Souls' Day (celebrated on November 1 and 2, respectively) became intermingled with traditions from pre-Hispanic harvest festivals.

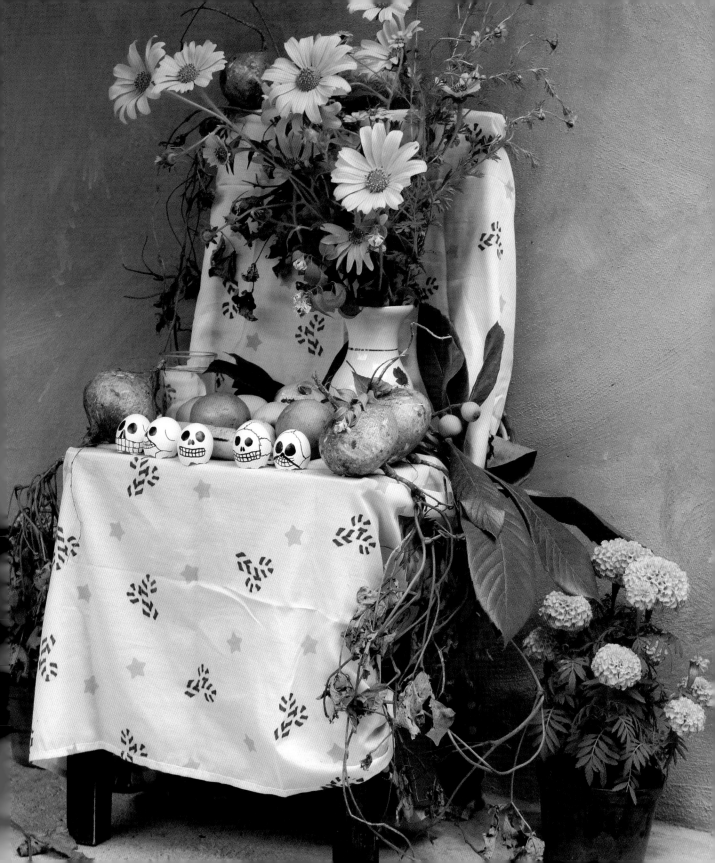

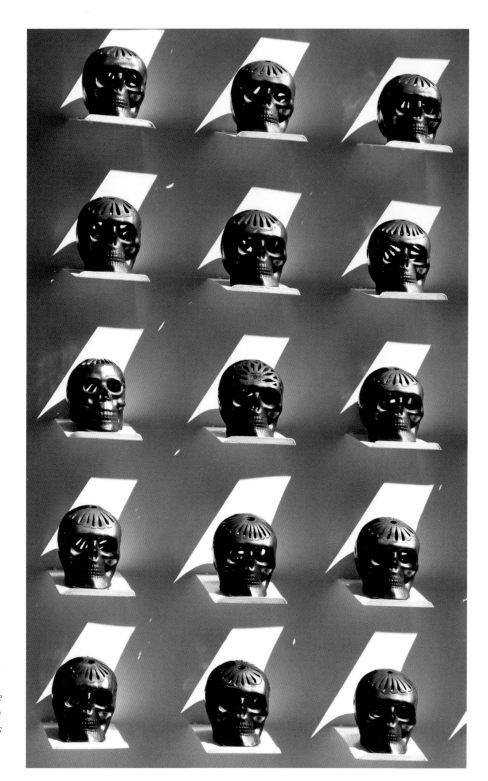

Black clay skulls, made in San Bartolo Coyotepec, are presented together as an installation in Oaxaca City. The repetition of the skulls makes a powerful statement, while the shafts of light add to the drama of the piece. The importance of the celebration inspires contemporary artists to experiment with unique ideas of expression.

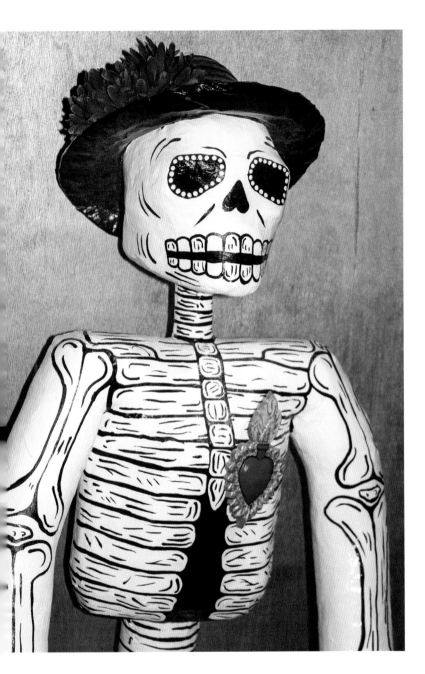

Folk artists often combine a variety of media in one piece, often requiring expertise with several media to achieve their goals. This large skeleton, carved from wood, is embellished with a brightly painted tin heart and a papier-mâché hat. Delicate black lines carefully delineate the bones. Common to the Day of the Dead skeletal art, this gentleman displays a wide grin and a playful expression.

Although the details vary from region to region and from village to village, the basic premise remains: the spirits of the dead will return home for a brief period. Their souls are not feared, but instead welcomed by their family members, who receive the spirits at home, offer them food and drink on an *ofrenda,* and then commune with them beside their graves during all-night vigils. While the Day of the Dead festivities in Mexico are perhaps the best known, some areas of Peru also celebrate the Day of the Dead in spectacular fashion.

While it may seem somewhat strange to those from other cultures that a festival dedicated to the dead should be a joyous occasion, the Day of the Dead is exactly that. For the Latin American people, death is accepted as inevitable, tied to the cycles of nature and harvest festivals of ancient times, and now coupled with the more recent introduction of the Christian tenet of eternal life after death. Combining equal parts of reverence for the dead, revelry to make them happy, and a certain mockery of death itself, the Day of the Dead is a festive and colorful celebration of life.

The visual imagery associated with the Day of the Dead plays a large

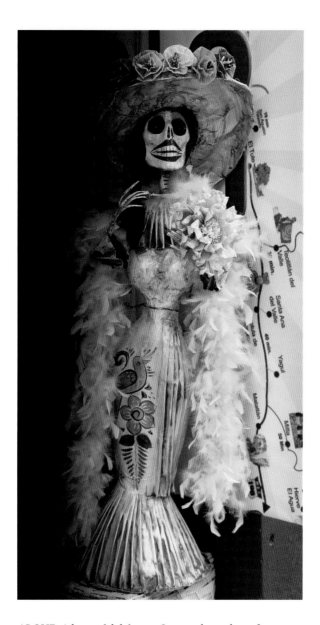

role in the aesthetic appeal of the celebration. Traditionally, the majority of art created for the Day of the Dead had an ephemeral quality. Meant to last only a short time, the materials used underscored the fleeting nature of life itself. Thus the care and effort with which each item was created honored the importance of life, however impermanent it might be.

The Day of the Dead is celebrated with a special zeal in many areas with large indigenous populations, such as Oaxaca and Michoacán, Mexico. As these are also regions that are renowned for their rich and vibrant folk art traditions, some of the most spectacular works of art in honor of the holiday have been produced by artisans in these areas. With the art they create for the Day of the Dead, the artists offer us a window into the cultural traditions associated with the holiday along with a subtle reminder that it is better to joke about death than to fear it. Those leering skulls and skeletons with their clattering bones are simply expressions of the Latin American sense of humor, coupled with an honest appraisal of human mortality and a genuine celebration of gratitude and thanksgiving for life's bounty.

ABOVE: A beautiful, life-size Catrina dressed in a fine gown, green feather boa, and large hat graces the front of a local store in Oaxaca City. Figures such as this play a large part in the festivities for the Day of the Dead. Businesses of all types join in the celebration by decorating their storefronts, doors, and windows.

FACING: The Spanish term luche libre *translates to "freestyle wrestling" in English. In Mexico the sport is very popular with fans of all ages. The wrestlers wear masks to disguise themselves and adopt "performance identities" that add to their larger-than-life personas. The strongly held belief that there is life after death supports the notion that the* luche libre *wrestlers will continue to wrestle for all eternity. The masked figure depicted here gives visual form to the breadth and depth of the belief.*

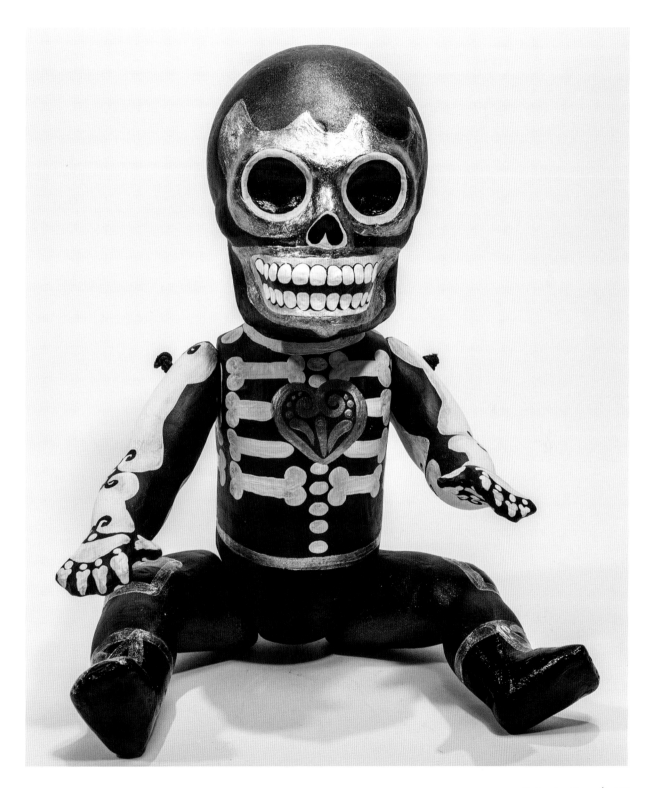

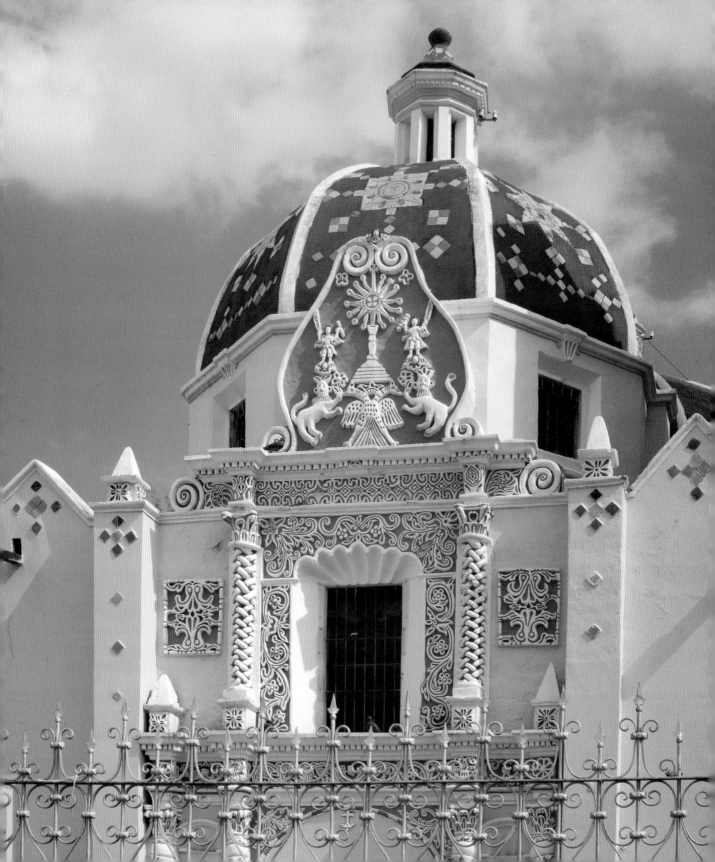

HISTORY OF FESTIVALS TO THE DEAD

As it is celebrated today, the Day of the Dead represents a synthesis of both New World and European traditions. The ancient Aztecs incorporated remembrances for the dead in their harvest festivals. When the Spanish arrived in the New World, they brought folk practices from early sixteenth-century Spain in addition to the official Catholic religion. Visits to cemeteries and feasting in commemoration of the dead were common pagan customs and rituals. Many believed that the dead would return to the earth once a year to partake of offerings of food and wine.

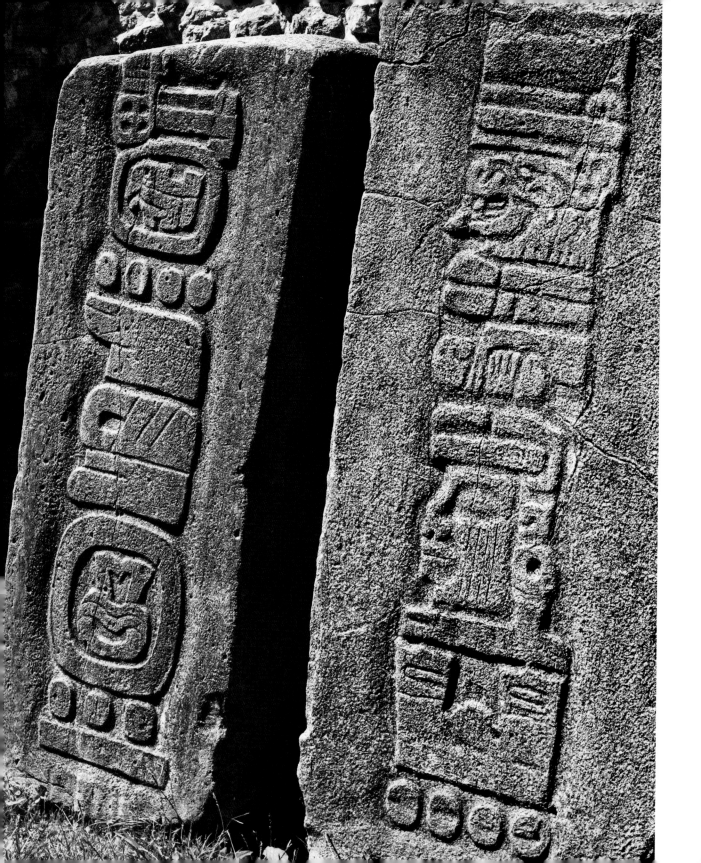

Catholicism introduced the Christian tenet of eternal life, along with the celebration of All Saints' Day and All Souls' Day. The European customs of making food offerings and feasting with the dead were readily accepted in Mexico, as similar practices had been important aspects of pre-Hispanic ritual. Over the centuries, the traditions became intermingled. As a result, contemporary Day of the Dead festivities combine aspects of Catholic theology with nature-based traditions from pre-Hispanic times.

In all Mesoamerican religions—including the Aztecs'—there was a recurring theme of interdependence and interaction between life and death, and between human beings and their gods. That life must arise from death was perhaps the most important tenet of Aztec cosmology. Aztec priests sacrificed their victims in an effort to appease the gods and ensure an abundant harvest. Every year in the early fall, the Aztecs participated in a festival dedicated to the dead in conjunction with the harvest. According to the accounts of early Dominican friars, the celebration involved a profusion of flowers, feasting, and dancing. Offerings to the ancestors accompanied these rituals as well. The souls of the dead were believed to return to visit the homes where they had resided. To properly welcome them, relatives provided a feast of favorite dishes, and would keep vigil through the night.

The Aztecs were not alone in such celebrations. Harvest festivals, held during the fall of the year by pagan peoples worldwide, frequently incorporated a remembrance of the dead. From the ancient Egyptians, who commemorated the death of Osiris, the god of life, death, and grain, to the Celts, whose holiday of Samhain marked the time when it was believed the Lord of Death would let the dead return to earth for one day, the concepts of harvest and death were frequently intertwined. Ancient customs ranged from placing food out for dead ancestors to performing rituals for communication with those who had passed over. It is unlikely that these parallels are mere coincidence. For ancient people, whose world was dominated by nature and the natural rhythms, a correspondence between the agricultural cycle and the human cycle of life would be logical.

With the arrival of Hernán Cortés and the Spanish in Mexico in 1519, the Aztec way of life was forever altered. The Spanish wanted not only to conquer the New World, but to also convert its inhabitants to Catholicism. While greed was undoubtedly Cortés's primary motivation, religion played a large role as well, and he sought to assure his own place in heaven through the conversion of the native population.

While the conquest was accomplished relatively quickly, converting the natives to Catholicism presented more difficulties. The first Spanish missionaries arrived in 1522, but the lack of a common language meant that the Indians misunderstood many of the Christian rituals, and reinterpreted them, in many cases perhaps even consciously, in terms of their own beliefs

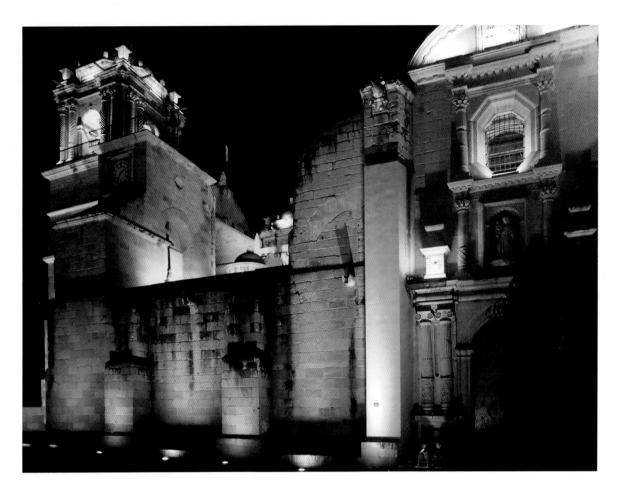

The Cathedral of Our Lady of the Assumption is located in the historic district in Oaxaca City. This view of the side of the cathedral shows the beautiful architecture illuminated at night.

and practices. As the Catholic friars learned more about the native religion, they discovered many concepts and rituals that were similar to those of the Christian faith. Where such similarities and overlap of traditions occurred, the Spanish capitalized on them in the hope of making Christianity more acceptable to the native population. When a feast day in the Catholic calendar occurred around the same time as an Aztec festival, the traditions were often combined.

As a result, the Christian celebrations of All Souls' and All Saints' days eventually merged with the harvest rites of the ancient Aztecs. Although the indigenous beliefs have changed and evolved over time, the ritual of making offerings to the ancestors remains intact, and the celebration continues to reflect both thanksgiving for the abundance of life and a profound respect for the dead.

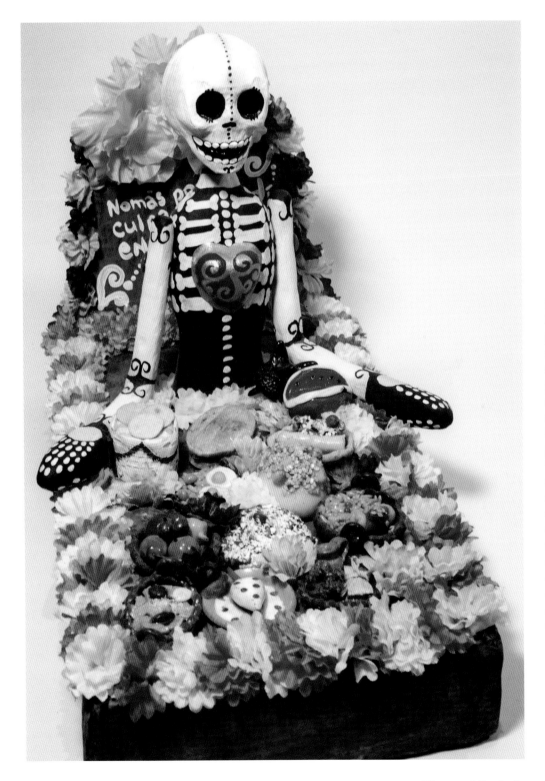

Surrounded by flowers, plates of food, and tortillas, a grinning papier-mâché skeleton sits comfortably in her decorated grave. Her white skeletal frame is adorned with black painted details. She represents loved ones who have passed away and are honored in the cemeteries with beautifully decorated graves. Her happy smile offers assurance that the next part of the journey is filled with joy.

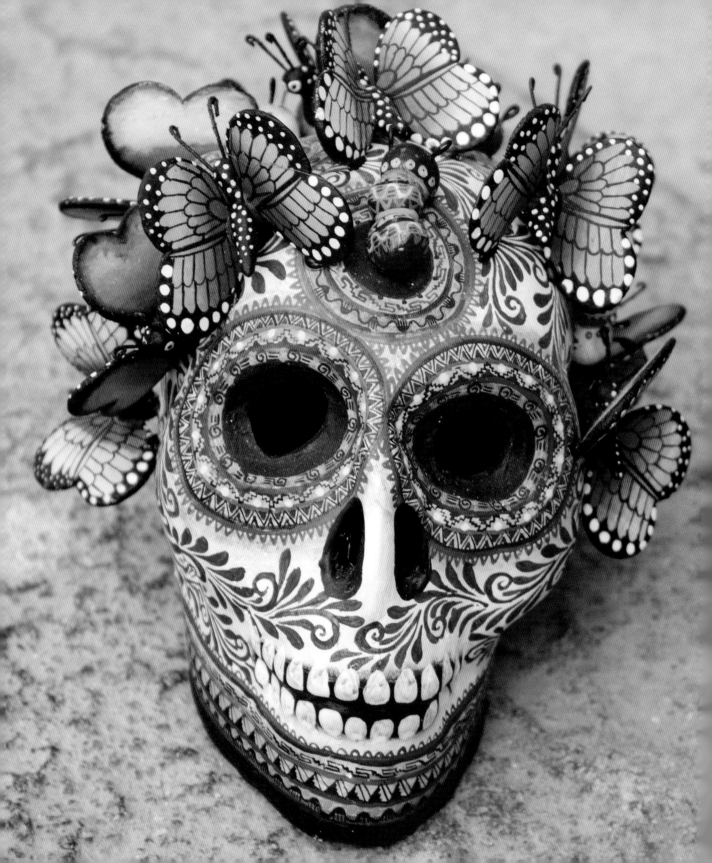

SKULLS AND SKELETONS

At its core, the Day of the Dead is a celebration of life and an honest appraisal of human mortality. Mexicans would rather joke about death than fear it. From the ancient stone carvings of the Aztecs to irreverent contemporary T-shirt designs, the skull remains the most iconic image associated with the Day of the Dead.

The use of skulls and skeletons in art and decoration originated before the conquest of Mexico, and pre-Hispanic imagery representing death is widespread. Archaeological sites from the Classic period (200–900 CE), such as the ball court at El Tajín on the Gulf Coast, contain numerous carvings of skulls and skeletonized figures. In southern Mexico and parts of Central America, the Maya often utilized skulls in architectural decorations.

It was in the post-Classic period (900–1520 CE), however, that the images of death became most prominent. The Aztecs excelled in stone sculpture and creating striking carvings of their gods. Coatlicue, the Earth Mother

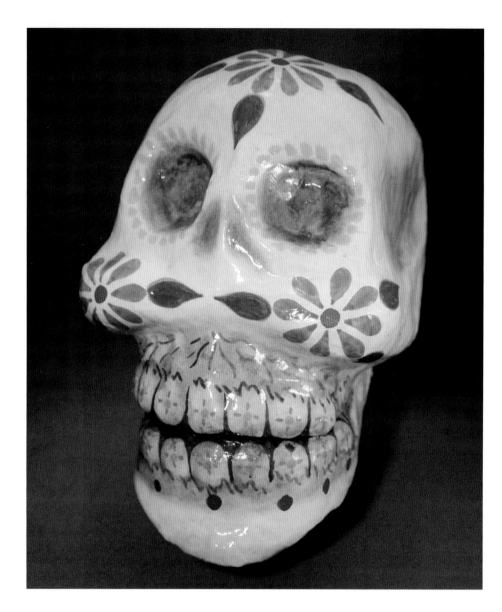

LEFT: Skulls created for the Day of the Dead are clearly meant to express the belief that death is a part of the journey of life. A large smile and decorated cheeks add to the whimsy of this piece.

FACING: Contemporary artist Néstor Omar Hernández Santiago, from San Juan Bautista Guelache, Oaxaca, is exploring new visual concepts with his clay skulls. Small skulls decorate the surface of the large head. Ears of pink corn are attached at different angles and surround the crown of the head. Hernández also experiments with a variety of colorants and firing techniques. His work depicts the intimate relationship between life (corn) and death (skulls). Most of Hernández's skulls are life size.

(also known as the goddess of life, death, and rebirth), was portrayed with a necklace of human hearts and a skull pendant. Most representations of this goddess emphasize both her motherly and deadly sides because the earth was seen as consuming, as well as regenerating, life.

The Aztecs also carved skulls on monoliths of lava, made masks of obsidian and jade, and wove the skull motif into garments. Throughout Mexico, archaeologists have discovered scenes of sacrifice dating from this time period, as well as pottery vessels in the forms of skulls and skeletons, and racks to display skulls of sacrificial victims.

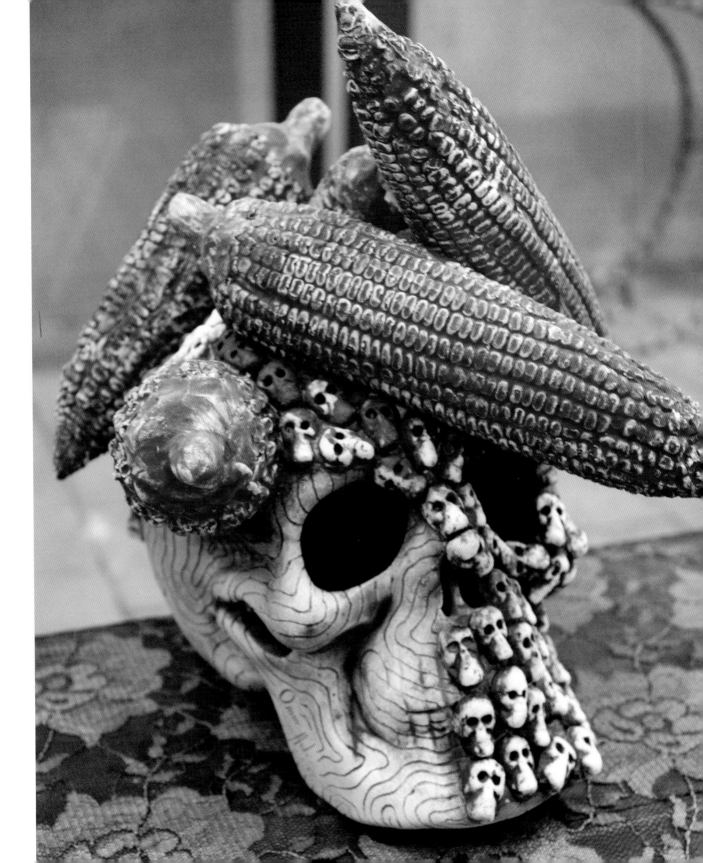

Brightly painted plaster skulls sport flowers on their heads. Painted with skill, each happy face grins with mischief.

Following the conquest, the Spanish attempted to suppress the indigenous skull art because it was not refined enough for their tastes. However, once Mexico won its independence from Spain in the early 1800s, skull art reemerged as a symbol of the new blended Mexican culture.

Today, skulls and skeletons figure prominently in all aspects of the Day of the Dead celebration. Folk art pieces can be found in virtually every shape, color, and size. Skeletal figures range from the very tiny—only a couple of inches tall—to larger than life. And like their Aztec predecessors,

During the holiday, large sand paintings are made in the parks, churchyards, and along the streets. Groups of students, representing various schools, use sand and colorants to create designs in relief. As the days pass, the images begin to show the passage of time and are swept away at the end of the celebration.

the artists use a variety of media—wood, papier-mâché, clay, and much more. Whimsical, fun, and limited only by the artists' imaginations, it is possible to find figures engaged in virtually every sport or hobby.

The wedding couple is also a very popular Day of the Dead theme. The bride and groom symbolize a love that will endure even after death. The *calacas* (skeletons) are usually depicted with full, happy smiles, in keeping with the belief that death is a natural part of life.

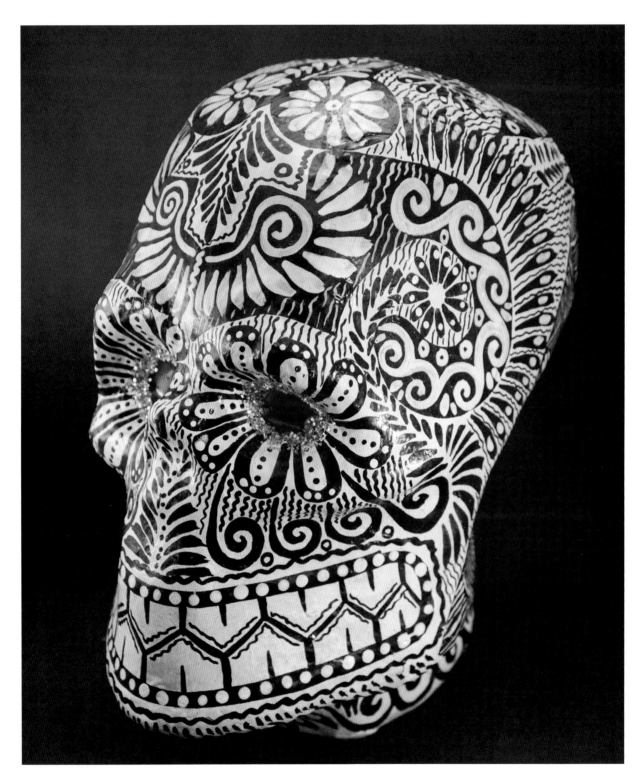

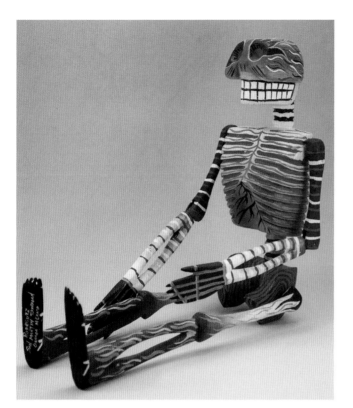

FACING: Crafted from papier-mâché, this black-and-white skull is sixteen inches tall. Careful observation reveals intricate black designs painted on a white background, while in some areas the palette is reversed and white designs are painted on a black background. The reversal of positive and negative space adds to the complexity of the symmetrical design. Bright pink plastic jewels ornament the eyes.

LEFT: Carved from wood and painted with bright contrasting colors, this skeleton from San Martín Toxpalan, Oaxaca, sports a wide smile. Stripes of many colors decorate and differentiate the skeletal features of the body.

BELOW: Eight members of the band gleefully entertain their listeners. Playing with abandon, the skeletal forms twist and turn in rhythm with their instruments. Carver Agustín Cruz Prudencio, from San Agustín de las Juntas, Oaxaca, expresses the important role of music in daily life as well as the concept of life after death. Carved from copal wood with a machete and several different knives, his figures stand six inches tall.

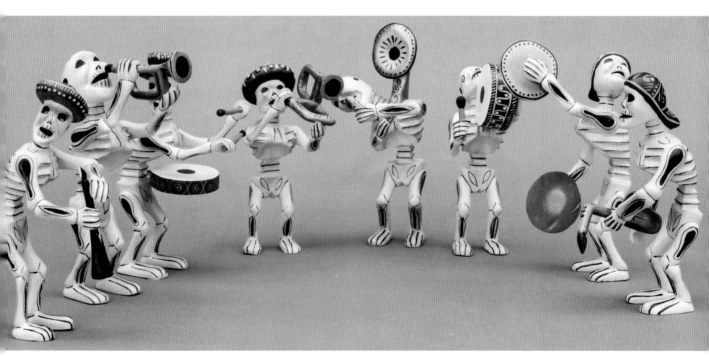

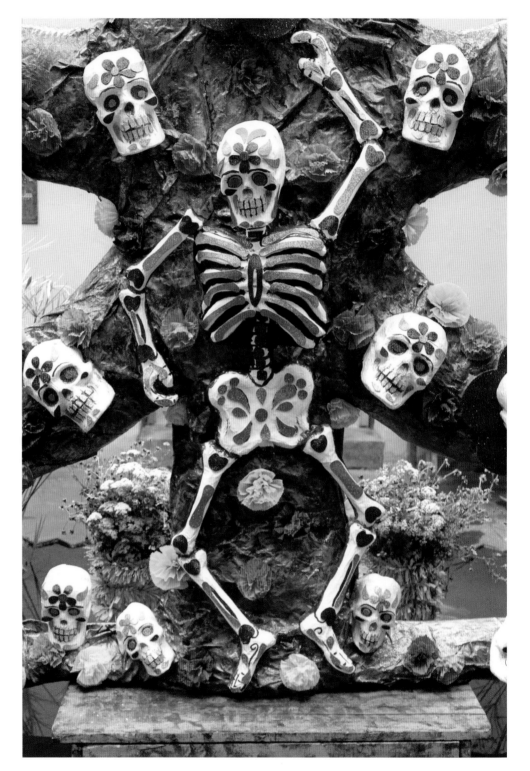

A life-size skeleton crafted of papier-mâché is attached to a large tree made from the same material. Individual papier-mâché skulls and paper flowers are also part of the installation. Located in the center of a small shopping area in Oaxaca City, this piece is a fine example of the community art that is created each year. The city begins to transform with decorations about a week prior to the holiday.

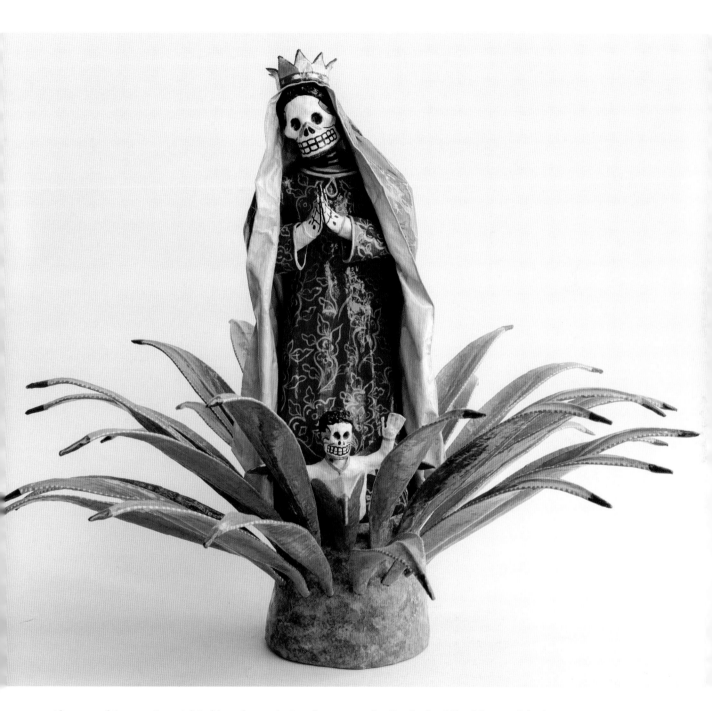

Also created from papier-mâché, this sculpture depicts the very popular Our Lady of Guadalupe and the Aztec Indian Juan Diego, who encountered her on the Hill of Tepeyac in central Mexico. As the patroness of Latin America, she has a large presence in the arts. Crafted by the highly regarded artist Joel Garcia from Mexico City, the sculpture stands about fourteen inches tall. The gown of Our Lady is embellished with delicate designs.

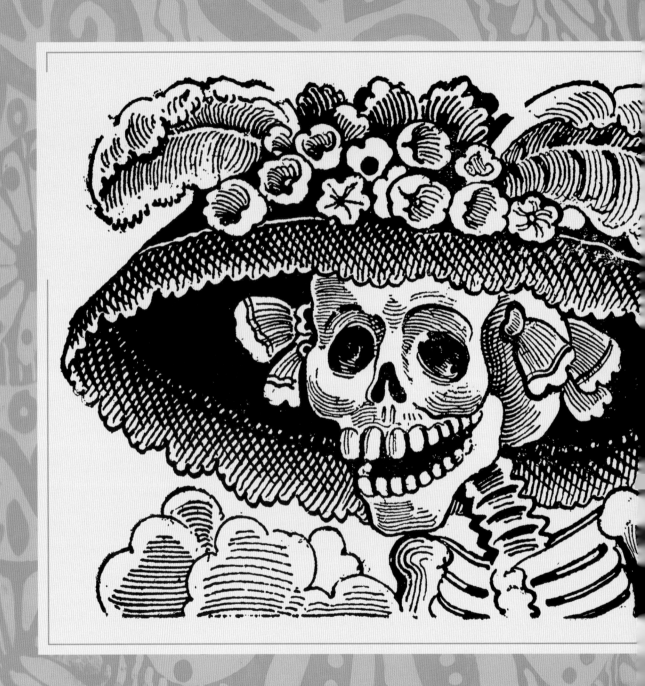

JOSÉ GUADALUPE POSADA

While the skeleton and skull imagery that predominates during the Day of the Dead celebrations has its roots in pre-Hispanic times, current artistic expressions owe much to the work of Mexican illustrator, political cartoonist, and printmaker José Guadalupe Posada. Posada often depicted politicians and other important figures as skeletons in his work. His intention was to poke fun at the wealthy and to remind people that, in death, all souls are equal.

Born in 1852 to a baker and homemaker in Aguascalientes, a city in central Mexico, Posada was raised in poverty. Although both of his parents

José Guadalupe Posada's most iconic image, La Calavera Catrina, *was created as a broadside in 1913. This image of her with a large-brimmed hat full of flowers and feathers is the one that has inspired and continues to inspire the work of many artists. Representing a woman of high social status and wealth, her skeletal face is a reminder that following life on earth, all living beings are equal and on the same journey.*

LEFT: Don Ferruco and His Love *by José Guadalupe Posada is a broadside printed in the early twentieth century. Don Ferruco was a figure found in popular lore in Guadalajara, Mexico.*

RIGHT: The Calavera of Cupid, *created in the early twentieth century, captures the elegance of a well-dressed woman. As the colonization of Mexico continued, European styles of dress became more prominent among the wealthy.*

were illiterate, Posada received an education from his brother, José Cirilo, an elementary school teacher twelve years his senior. Posada's artistic talent was evident from an early age, when be began copying the artwork he saw on religious cards and small pictures. He eventually attended the art academy in Aguascalientes for a brief time.

At the age of just sixteen, Posada began working at José Trinidad Pedroza's printing house, one of the best in the country. There he learned the printmaking techniques for lithography and wood engraving. Within three years, Posada was the head cartoonist of *El Jicote* (The Wasp), a critical newspaper published by Pedroza. The two men became friends and business partners, and Pedroza eventually opened a second printing

house in León, Guanajuato. Posada met and married Maria de Jesus Vela in 1875, and they had one child who died at an early age.

Posada and Pedroza illustrated newspapers, magazines, books, and commercial items such as cigarette boxes and matchboxes. The business flourished until a catastrophic flood in 1888 forced Posada to move to Mexico City, and his partnership with Pedroza was dissolved.

Soon after arriving in Mexico City, Posada published a series of drawings in *La Juventud Literaria* (The Literary Youth). The introduction was penned by Ireneo Paz, the grandfather of famed writer Octavio Paz. Of Posada, Ireneo Paz wrote, "we guess he will become the best Mexican cartoonist," a statement that would prove to be prophetic. Posada's first regular employment in Mexico City was with a publication for which Paz served as editor, *La Patria Ilustrada*.

Posada lived and worked during a difficult time in Mexican history. The country was ruled by the dictator Porfirio Díaz, who remained in power for over thirty years. The vast majority of the population was poor and illiterate, while the wealthy aristocrats looked to Europe for style and fashion. Although Posada satirized people of all classes, it was his rendering of the aristocrats and their ridiculous posturing that remains the most popular of his body of work.

For the working classes, who lived a miserable existence under Díaz, Posada's illustrations showed the disdain they felt for the corrupt government. His illustrations also made the stories and news items easier to grasp.

Posada eventually joined the staff of the publishing firm of Antonio Venegas Arroyo, for whom he created a number of book covers and illustrations. Around this time, he also met Manuel Manilla, an engraver, who taught him how to create rich shades of gray and how to do more precise and delicate drawings.

In time, Arroyo and Posada teamed up with poet Constancio Suárez and began to publish cheap one-page leaflets with brightly printed graphics that reported current events and the issues of the day. It was here that the *calaveras* tradition began, as they presented satirical rhymes illustrated with skulls and skeletons that usually referred to the hypothetical death of a politician or celebrity.

Although popularized by Posada, the use of skeleton and skull imagery in Mexican prints did not originate with him. In the 1870s, another artist, Santiago Hernandez, frequently depicted politicians as skeletons with the intention of casting them in a distasteful light. Posada continued the tradition, adding his own touch of humor. Dressed in various costumes, Posada's skeletons offered wry commentary on the vanities of life and were vehicles for satire. His masterpiece, La Catrina, the most iconic figure associated with the Day of the Dead, is discussed in greater detail in the next chapter.

These calaveras, *created as a book illustration in 1931 by the well-known painter and muralist José Clemente Orozco, are kicking their heels and dancing to the music. Full of energy and vigor, their expressions convey delight.*

As a result of his political critiques, Posada was perennially out of favor with the ruling class. He lived in poverty and, along with his bosses, was periodically jailed. Posada died in 1913, a widower without children, and was buried in a common grave. At the time of his death, however, Díaz had already been forced out of power, and the long, difficult revolution that Posada had helped to provoke was well underway.

Although Posada's work was largely forgotten by the end of his life, famous Mexican muralists Diego Rivera and José Clemente Orozco both knew the artist and credited his work as an influence on their own. In the 1920s, the French artist Jean Charlot discovered Posada's work while visiting Rivera in Mexico and brought it to a wider audience.

An expert and prolific printmaker, Posada created over twenty thousand images during his career. With a style that is easily identified throughout Mexico, he is often heralded as the father of the Mexican artistic tradition, and Day of the Dead art in particular.

The Calavera of the Happy Widow *by Manuel Manilla, a contemporary of José Guadalupe Posada, is a broadside printed in the late nineteenth century. By that time in Mexico's history, artists were using* calaveras, *or skeletal figures, to illustrate broadsides commenting on political and social events of the time.*

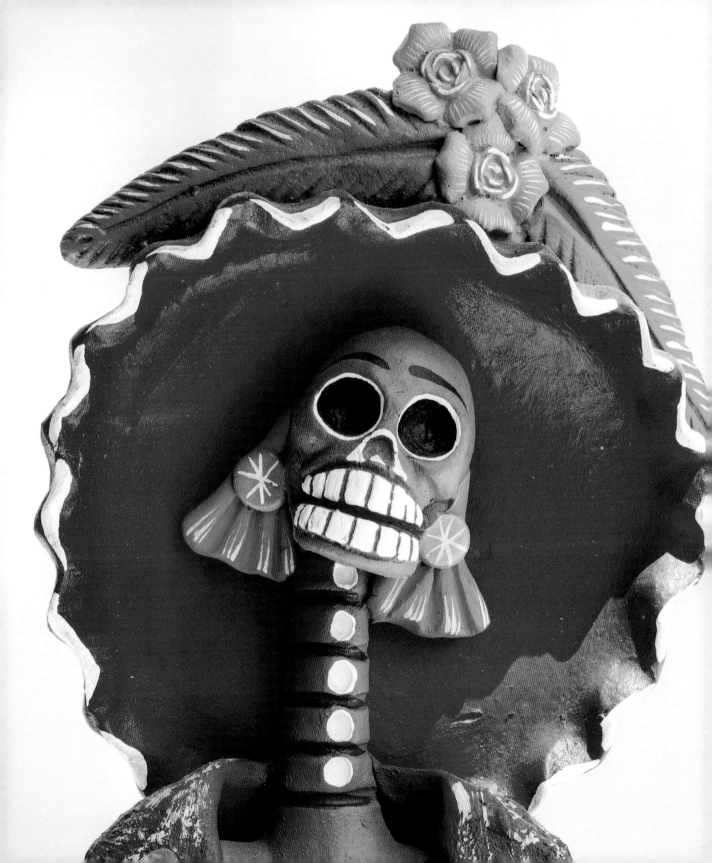

LA CATRINA

Of the many images and symbols associated with the Day of the Dead, José Guadalupe Posada's image of La Catrina, an elegant and well-dressed female skeleton wearing a large, fancy hat, is the most popular and well known. Posada created the first image of her, a zinc etching, around 1910–1913 as an illustration for a leaflet. Originally he called her Calavera Garbancera. *Calavera* means "skull" in Spanish, and *garbancera* was a derogatory term in the early twentieth century for people of indigenous descent who denied their own cultural heritage and embraced and imitated European style and customs. Posada's intent was to poke fun at the ridiculous posturing of the Mexican aristocracy in the prerevolutionary era, and make the point that, in death, all social classes are equal. Later, the elegant skeleton came to be known more commonly as La Catrina, the female version of a *catrín,* meaning a dandy or fancy man.

If José Guadalupe Posada is the father of Day of the Dead art, then it may also be said that, once Posada was gone, Diego Rivera became a doting stepfather to Catrina—he loved her, adopted her, and raised her as his own. While Posada's image is a head and bust, Rivera depicted the full figure of Catrina in his 1948 mural *Dream of a Sunday Afternoon in Alameda Park.* The fifteen-meter-long mural contains images of some four hundred

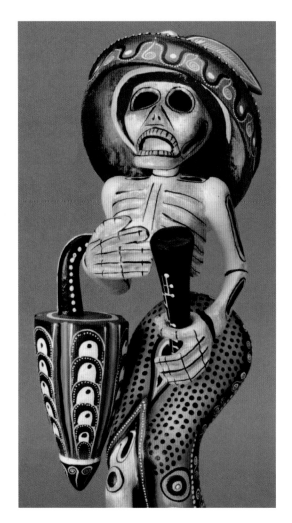 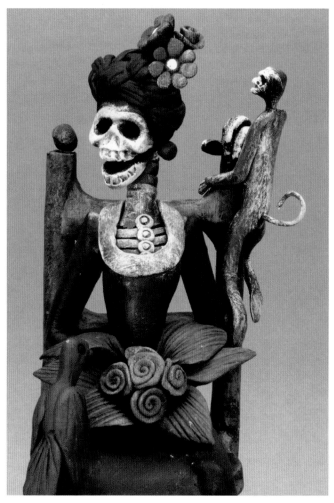

LEFT: This figure of Catrina was carved from copal wood by Manuel Cruz Prudencio of San Agustín de las Juntas, Oaxaca. While the carving captures the essence of Catrina, the artist's individual approach is apparent. The hat covering her head shades a very expressive face with large eyes and a wide mouth. Holding an umbrella and musical instrument, she stands proud. The details embellishing the figure were painted by Manuel's wife, Ruvi Martínez Fabian.

RIGHT: Images of Frida Kahlo, the famous Mexican artist, appear and reappear in all forms of media. She is best known for her self-portraits, which frequently included her pets. This delicately crafted clay sculpture shows Frida with a parrot and a monkey, two of her favorite animals. Her elegant stature is enhanced by her beautiful gown and upswept hairstyle.

major figures in Mexican history. Catrina appears front and center, arm in arm with her creator, Posada, and holding hands with a young Diego Rivera, while Rivera's wife, Frida Kahlo, looks on from behind. Originally displayed in the Hotel Del Prado, which sustained irreparable damage in the 1985 earthquake in Mexico City, the mural survived and was moved across the street to the

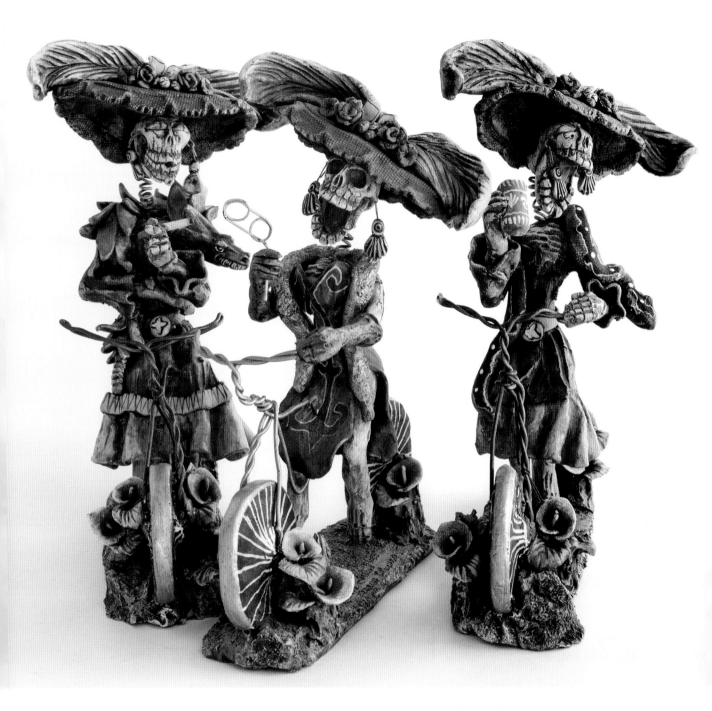

Three jazzy Catrinas are ready for a bicycle ride. Their outrageous outfits, full of ruffles and flouncy details, are sure to attract the attention of onlookers. Colorful calla lilies surround the wheels of the bicycles. Created in clay by José Juan Aguilar of Oaxaca, Mexico, their expressive faces and wide smiles convey the pleasure provided by an enjoyable outing.

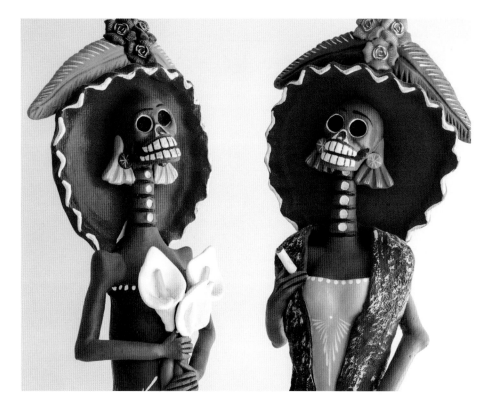

ABOVE: *Two whimsical clay Catrinas, painted with acrylics, are dressed for an elegant evening on the town wearing brimmed hats decorated with flowers and large leaves. The Catrina on the right wears a bright yellow gown and blue shawl with blue earrings. The Catrina on the left wears a strapless blue dress with yellow earrings and holds three lovely white calla lilies. Their graceful necks, decorated with small circles, suggest their skeletal structure.*

Museo Mural Diego Rivera, a facility that was built specifically to house it.

Although Rivera clearly took inspiration from Posada's original etching, he gave Catrina an identity beyond Posada's, dressing her in an elegant outfit, complete with a feather boa. Rivera pays homage to Catrina's indigenous roots, as well; a closer look at her boa reveals that it is the form of a plumed serpent, a clear reference to one common representation of Quetzalcoatl, an important figure in pre-Hispanic mythology. In perhaps yet another nod to her pre-Hispanic legacy, the feathers on the boa also bear a striking resemblance to the leaves of a corn plant, an important crop to the indigenous peoples of Mexico.

Through Catrina, both Posada and Rivera captured the intimate relationship Mexicans have with death. Over time the original meaning faded and she has become a popular Mexican figure representing death itself, and the most iconic figure of the Day of the Dead celebration.

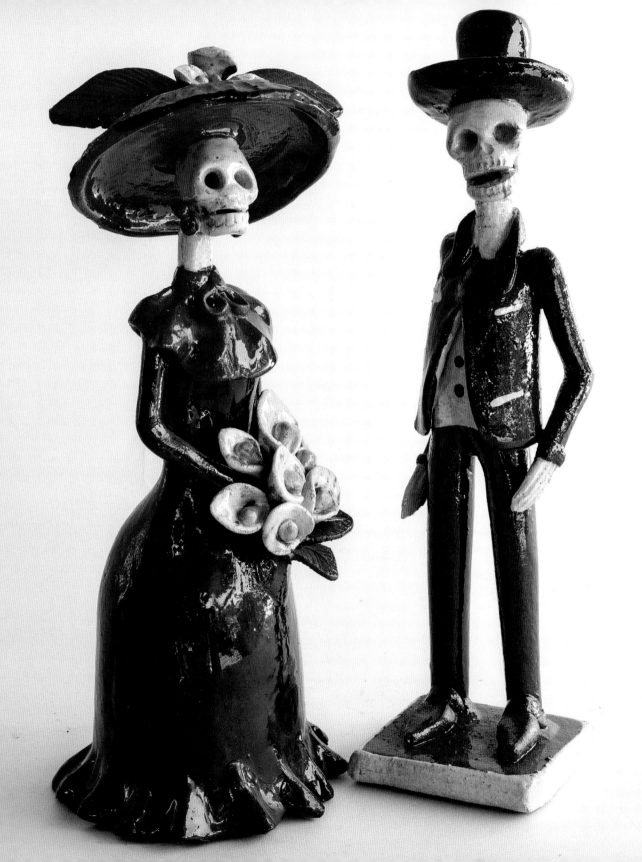

Through the years, Catrina has served as inspiration for many artists. Today there are numerous depictions of Catrina, limited only by the imaginations and creativity of the artists themselves. While the elegant dress and boa are traditional, more contemporary images often show her with a parasol and sometimes a cigarette, as well. Catrina is represented in virtually every art form associated with the Day of the Dead—including papier-mâché, Talavera ceramics, wood-carvings, *papel picado,* and sugar and chocolate confections. More recently, the popularity of the Hollywood movie *Frida* (2002) gave rise to a new "Frida Kahlo Catrina," in which a skeletal image with Frida's iconic "unibrow" is placed in a setting reminiscent of one of the artist's well-known self-portraits.

The image of Catrina can be seen all over Mexico, and is particularly evident during the Day of the Dead. In parades and other festivities it is common to see her embodied as part of celebrations of the Day of the Dead both in Mexico and the United States.

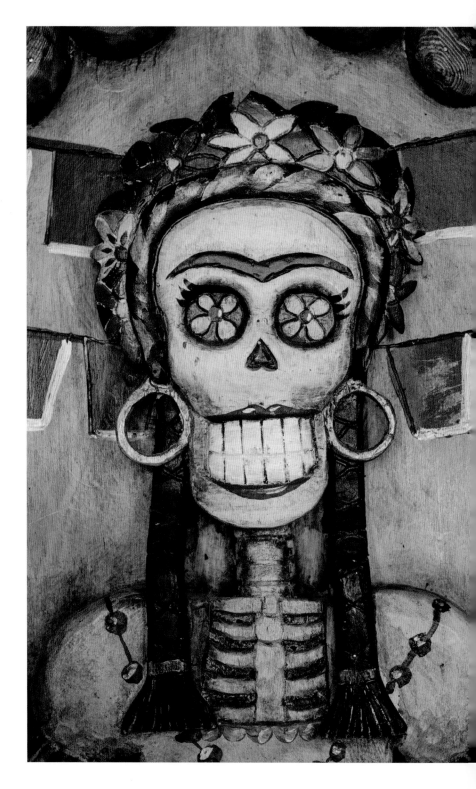

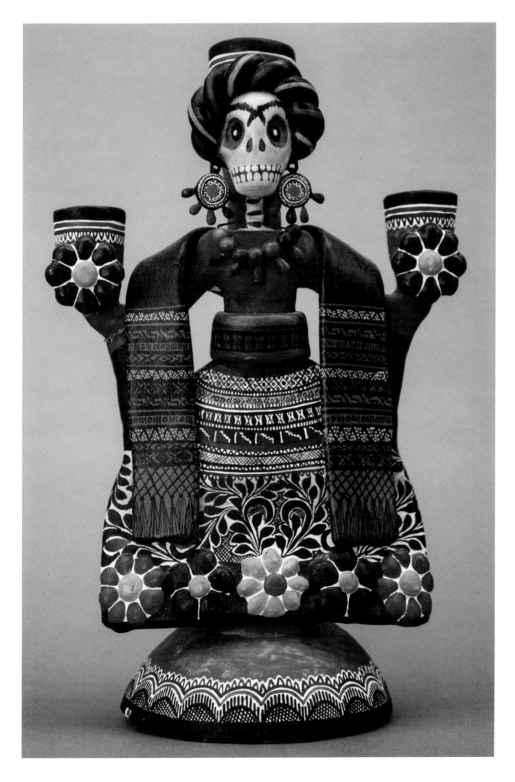

FACING: A smiling Frida wears her hair laced with ribbons and flowers. Her long braids drape below her shoulders. Large eyes are depicted with flowers and twinkle with mirth. Hoop earrings add sparkle to her face. The artist depicts Frida with a wide, irresistible grin. A blue-green background lends a pleasing contrast to the warm colors found in her figure.

LEFT: The family of Alfonso Castillo Orta from Izúcar de Matamoros, Puebla, is highly regarded for their painted clay figures. Their palette of colors includes deep, rich tones of red, blue, green, yellow, and black. This figure of Mexican artist Frida Kahlo, easily recognized by her eyebrows, is the work of Alfonso Castillo. Created in clay, fired in a kiln, and painted with intricate details, she wears a shawl like that of the indigenous women of Mexico. Like her namesake, this Frida is wearing large earrings and a necklace. The figure is twelve inches tall.

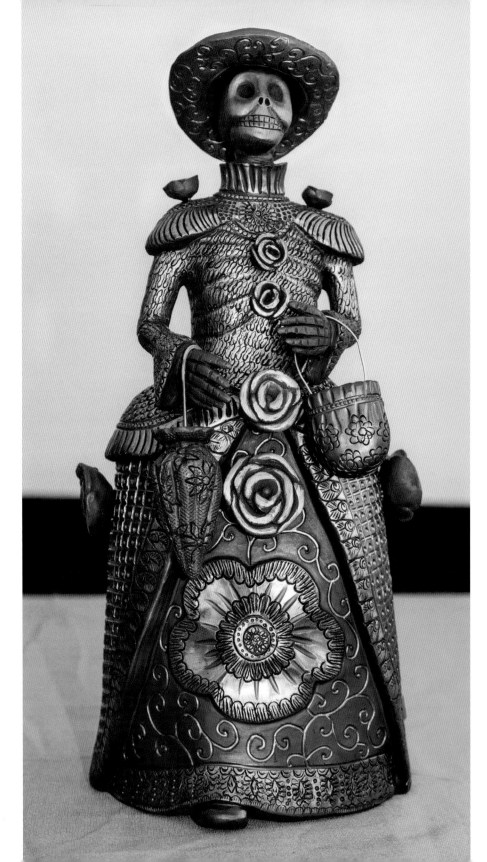

RIGHT: This magnificent clay Catrina is the work of Magdalena Pedro Martínez, from San Bartolo Coyotepec, Oaxaca. After sculpting her figures, Martínez adds detailed ornamentation with small amounts of additional clay, then carves a delicate but complex series of patterns into the figure using fine tools. Once the clay has dried to a leather-hard stage, she burnishes certain areas to produce a shine. In this example, the flowers are highly burnished. When the burnishing is complete and the piece has dried completely, it is fired in an underground kiln. During the firing process the clay turns black, leaving the burnished areas shiny and the remaining areas with a matte finish, as in this spectacular fourteen-inch figure.

FACING: Catrina in all of her elegance portrays many personalities. Manuel Cruz Prudencio from San Agustín de las Juntas, Oaxaca, carved this twelve-inch figure from copal wood with a machete and several knives. Her parasol is open to shade her from the sun. A full form belies the fact that she is a skeleton. Dressed in an intricately decorated gown, she is sure to be noticed. Manuel's wife, Ruvi Martínez Fabian, painted the figure.

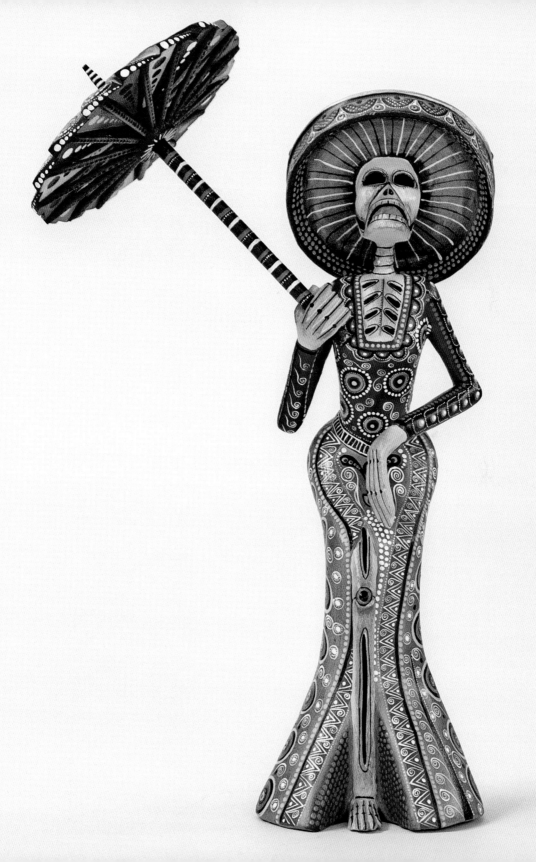

MARKET ART

Everyone participates in the preparations for the Day of the Dead. Family members work together to clean and decorate the graves of departed loved ones, and to construct elaborate home altars, or *ofrendas,* to welcome them upon their return. The first stop for virtually everything that will be needed is the local market, and in the days and weeks leading up to the celebration, it becomes a hub of activity.

Local Markets

Traditionally, decorations for the Day of the Dead had an ephemeral quality. Meant to last only a short time, the materials used symbolized the fleeting nature of life itself. The care and effort with which an item was created underscored the importance of life, however fleeting and impermanent it might be.

As the holiday approaches, many of the stalls in the bustling markets become works of art themselves, boasting dazzling arrays of colorful candy skulls, skeleton figurines, paper banners, and the traditional "bread of the dead" known as *pan de muerto*. There are also candles of every shape and size, and fragrant bundles of copal incense, along with traditional three-legged ceramic burners. The copal is burned both on the *ofrendas* and at cemeteries to welcome and guide the returning souls. On surrounding streets, impromptu flower markets spring up as large pickup trucks arrive, their beds spilling over with brilliant cargoes of bright gold and orange marigolds, fuzzy magenta cockscomb, and bundles of delicate baby's breath.

Sugar Skulls

The most festive icon of the Day of the Dead celebration is undoubtedly the sugar skull. Sugar art dates back to the colonial period in Mexico.

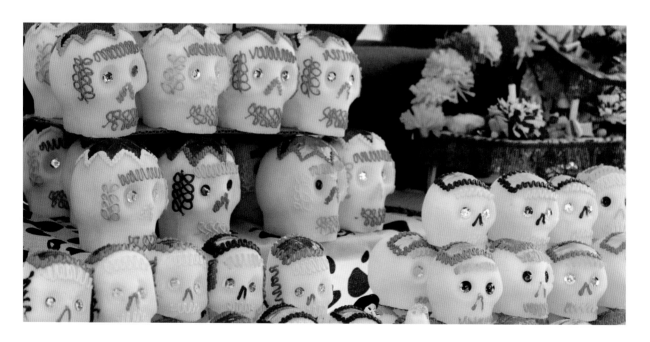

Market stalls in Mexico brimming with sugar skulls are a common sight a week before the holiday. Made in molds with boiled sugar, the skulls are decorated with colored icing, foil papers, and fabric trims. A popular addition to ofrendas and cemetery graves, they are also given as gifts to family members and friends as tokens of friendship and love.

Too poor to buy fancy imported European church decorations, the faithful learned to use sugar, a crop they had in abundance, to make figures such as angels and lambs for religious festivals.

Skulls made of sugar came into popular use for the Day of the Dead. Traditionally, the skulls represented a departed soul. The name of the person being honored was written on the forehead of the skull, and it was placed on the grave or home *ofrenda*. More recently the skulls have also become popular gifts, exchanged by friends and sweethearts as a symbol of a bond of affection so strong it will endure not just throughout this life, but the next as well.

To create the skulls, artisans boil sugar and pour it into clay molds. Once the sugar has cooled and hardened, they remove the skulls from the molds and decorate them with colorful icing and shiny bits of foil. Other types of sugar art are created as well, such as coffins with pull strings to raise the tiny corpses from the dead. The sugar art is rarely eaten; its primary purpose is to adorn the altars and tombs as a sweet delight for the visiting spirits.

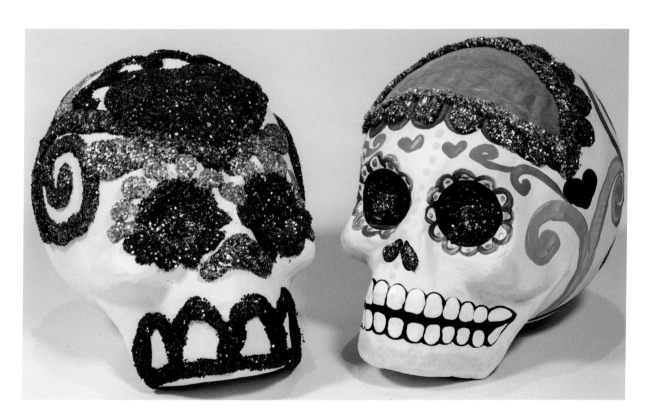

Skulls are crafted from many different materials. Some artists prefer to use plaster because the potential for adding decorations is much broader. These skulls have been painted and embellished with glitter.

Skeleton Figures

Skeleton figures made of wire, papier-mâché, cardboard, tin, or wood abound at the markets. Ranging from tiny to larger than life, the figures depict people from all walks of life: office workers toiling at their computers, police officers, fancy top-hatted men, and elegant women. Skeletal figures used to decorate a grave or home *ofrenda* are often chosen to represent the occupation or an interest of the deceased. The bridal couple is an ever-present theme, symbolizing a love that will last for eternity.

Three skeletal papier-mâché angels open their arms in joy. Their wings are made of cardboard, and large flowers and leaves, painted with bright contrasting colors, decorate their gowns. Spots of glitter provide details. These six-inch smiling figures are typical of the merchandise found in the markets.

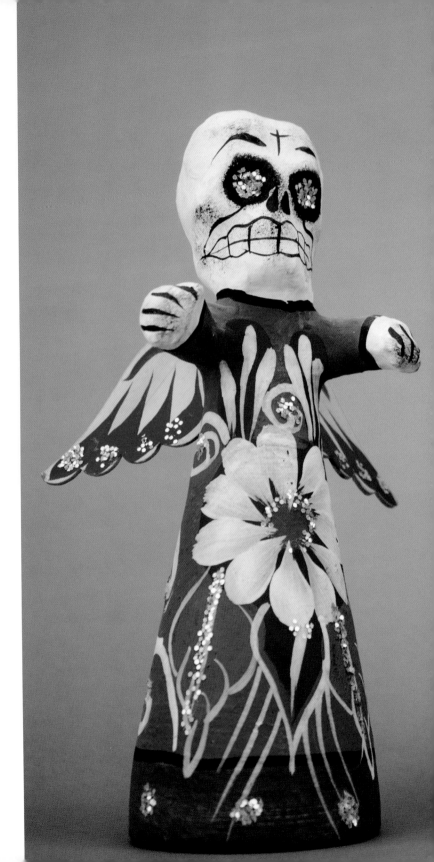

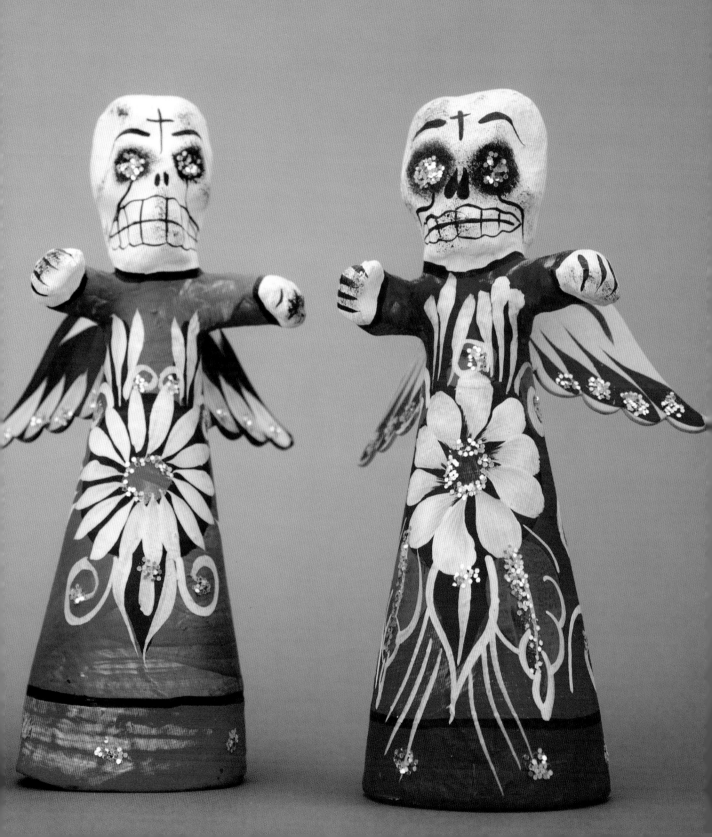

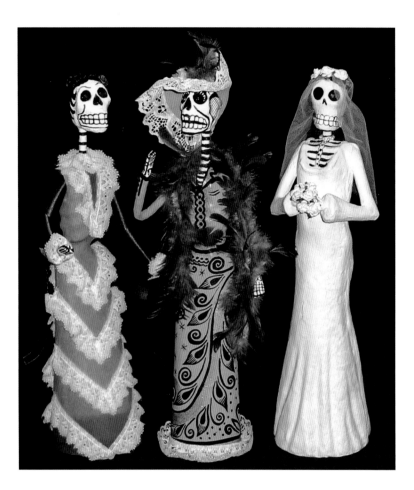

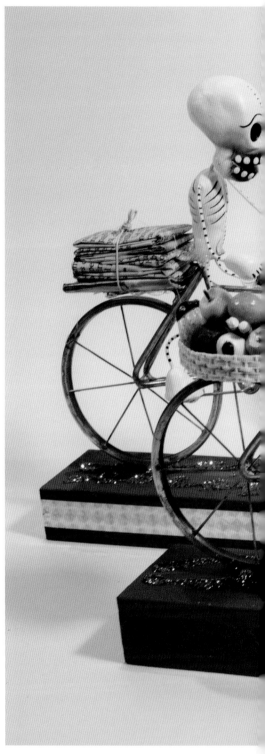

ABOVE: The humble medium of papier-mâché is used to create all types of figures for the holiday. A pretty, young skeleton in this trio of figures wears a beautiful dress with white ruffles cascading to the floor. In the middle of the group is Catrina in her finest. A long blue boa complements her dress of the same color, while swirling patterns embellish it. A bride dressed in white completes the trio. Always a popular figure, she is elegantly dressed for her special day. The figures stand fourteen inches tall.

RIGHT: Four vendors use their bicycles to transport goods to market. A newspaper seller rides with friends who sell fruits, vegetables, and baked goods. Each bicycle is approximately six inches long. The skeletons, made of papier-mâché, appear to enjoy their work.

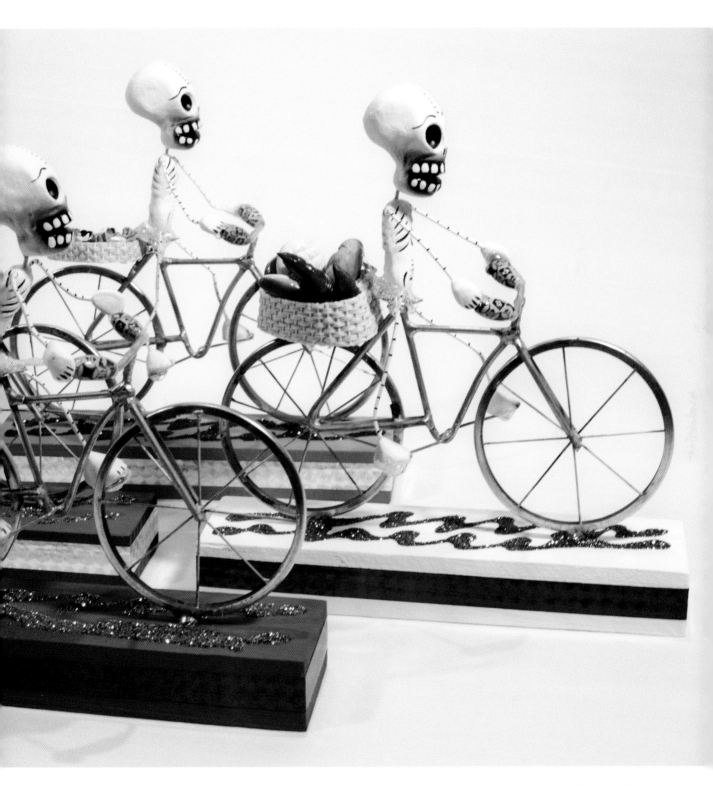

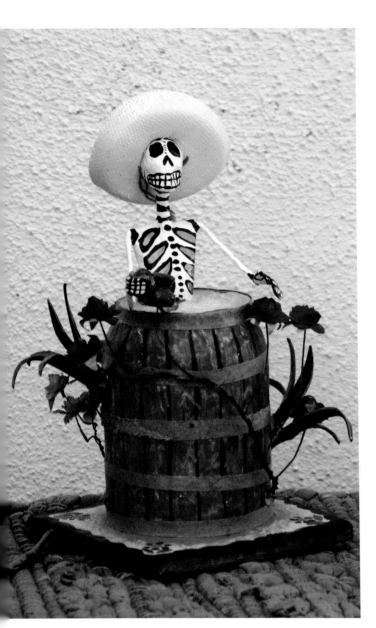
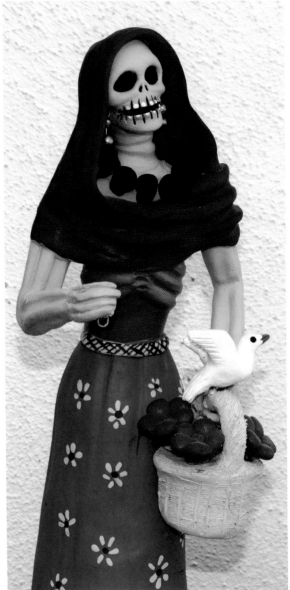

LEFT: A clown, standing in a barrel decorated with plastic flowers, has a smile that invites laughter. Made from the humblest of materials, this figure captures the whimsy and fun of the celebration.

RIGHT: A lovely lady dressed for a party carries a beautiful yellow basket, red flowers, and a dove in her hand. Made from clay and standing about twelve inches high, she sports a big grin. A red cape covers her head and shoulders, and large black beads drape around her neck. Bright pink and blue acrylic paints were used to decorate her blouse and skirt.

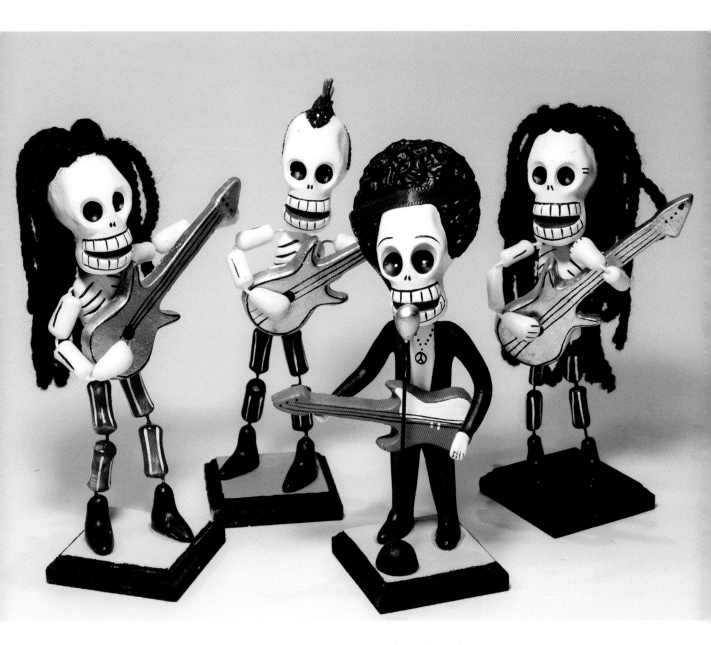

This quartet of musicians is eager to perform for a willing audience. Each member of the group is dressed, coifed, and ready to play. The leader of the group sports a pink guitar and a coordinated headband. The belief in life after death, expressed through Day of the Dead art, assures the good times will continue.

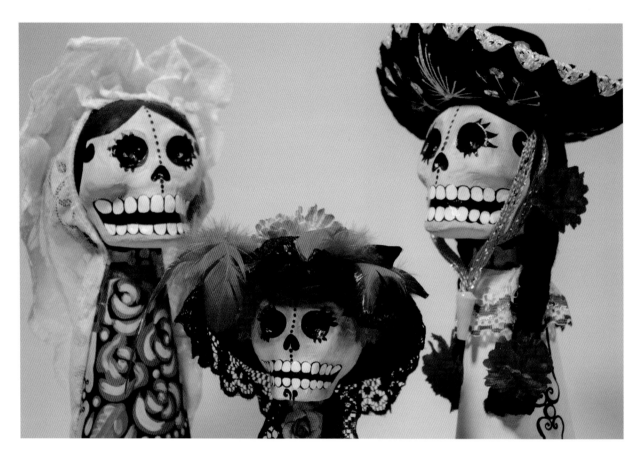

Festivities for the Day of the Dead include parades, fiestas, and community events. Women of all ages dress in beautiful, indigenous clothing and many enjoy painting their faces. Inspired by the celebrations, these papier-mâché figures capture the spirit of the holiday with their colorful clothing and smiling faces.

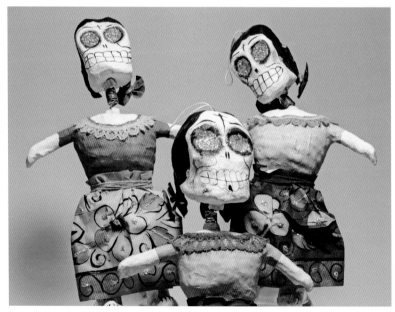

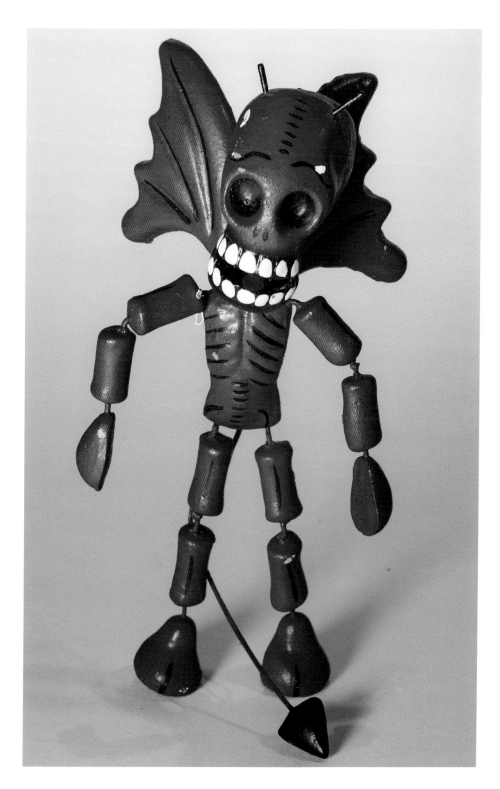

The devil is a popular subject for the Day of the Dead. Always portrayed with a happy face, he doesn't evoke fear of the afterlife. The markets teem with small trinkets such as this for use as gifts and as decorations in the home.

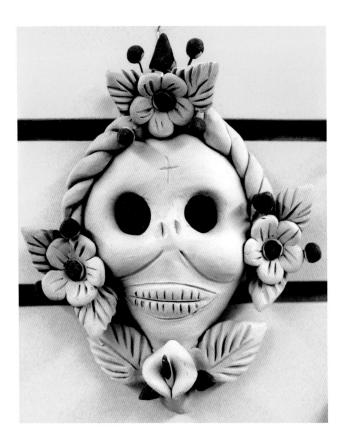

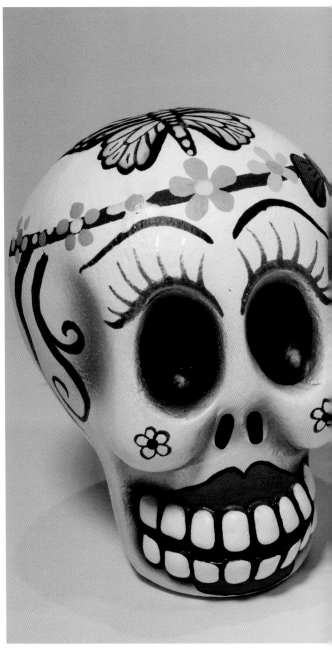

The village of Santa María Atzómpa in Oaxaca is known for its unique style of unglazed ceramics. Objects are crafted from a dark gray clay that transforms to a creamy beige color after it is fired in the kiln. The technique of appliqué is used to apply decorative details. In this example, the braided hair surrounding the face, the flowers, and the leaves add flair to the skull. Natural colorants made from minerals and plants are used to achieve different colors, such as the small touches of red seen in this piece. Simple tools are used to carve or incise designs in the clay.

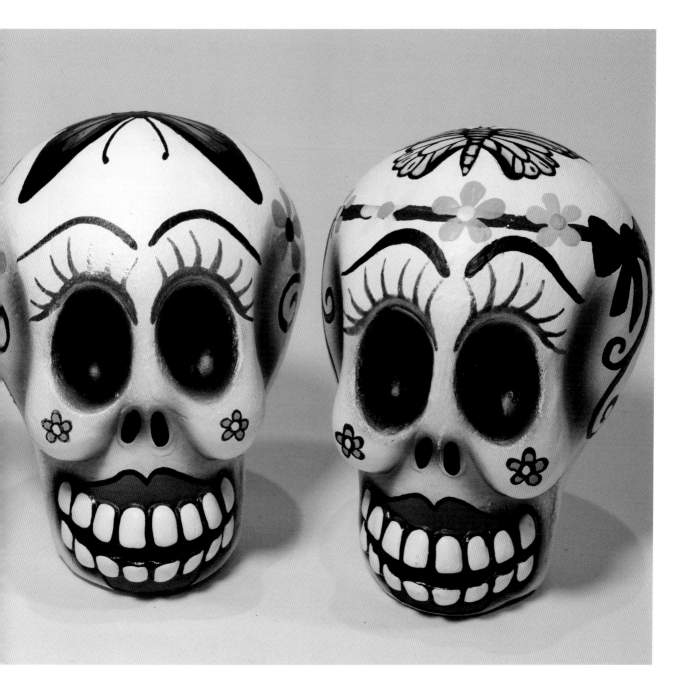

A trio of smooth, white clay skulls offered the artist a canvas for painting fanciful expressions.
The skull forms were made in molds and fired in a kiln. Bright red lips show off the pearly white
teeth. Arching eyebrows and blue eyelashes enhance the large black eye sockets, while butterflies,
flowers, and swirls decorate their crowns. Their animated expressions guarantee a fiesta.

Papel Picado

Bright tissue paper banners of *papel picado* (punched paper) add a festive touch to virtually all celebrations in Mexico. The color schemes and designs vary depending on the holiday being celebrated. For the Day of the Dead, *papel picado* is often created in vibrant tones of pink, orange, and purple, and features designs of skeletons, skulls, crosses, and tombstones. Hung together like a string of flags, the banners flutter above city streets and adorn the high ceilings of colonial homes and buildings. Strings of *papel picado* are also usually hung in front of or above the *ofrendas*.

The tradition of *papel picado* dates from pre-Hispanic times, when papermaking thrived throughout Mesoamerica. Artisans used the bark of the amate tree, a type of fig, to make a rich brown- or beige-colored paper. Cut-paper figures representing human and animal spirits were used in Aztec ceremonies. After the Spanish conquest, *papel de china* (tissue paper) was introduced and became the material of choice for *papel picado*.

Today, *papel picado* artists create intricate designs that may take many hours to cut. Using awls, chisels, and special cutting blades, skilled artisans can work with as many as fifty sheets of tissue paper at a time. A pattern placed over the stack of tissue paper guides the cutting of designs, which often include delicate windowpane backgrounds. The complex designs require a keen ability to envision the use of negative space. As the final touch, borders along the bottom and sides of the flags are usually scalloped or zigzagged.

As with many of the traditional arts in Mexico, there are regional variations and areas of specialization. Some of the best *papel picado* comes from the village of San Salvador Huixcolotla in the state of Puebla. Artists there make decorations for the Day of the Dead, Mexican Independence Day, Christmas, and many other holidays, as well as custom designs for weddings and other special events.

Pan de Muerto

The culinary arts have a role in the Day of the Dead as well. During this time of year, markets and bakeries feature fanciful loaves of bread known as *pan de muerto* (bread of the dead). A slightly sweet egg bread, similar to challah, *pan de muerto* is baked in the shape of skulls, crossbones, and skeletons, and is commonly flavored with orange, anise, or almond. Loaves are used to decorate *ofrendas* and graves, as well as being a special treat for the living.

Here again there are variations based on region and personal taste. The most traditional loaves of *pan de muerto* are round, with a central raised knob of dough, representing the skull, and crossbones-shaped decorations radiating from the central knob. The circular shape is said to represent the circle of life.

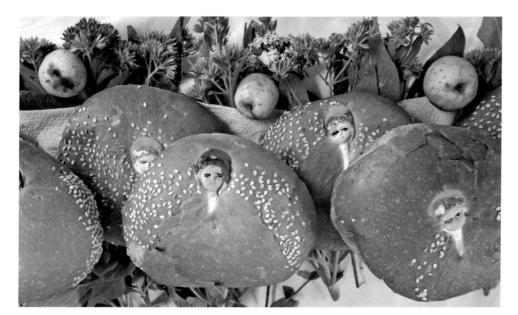

Rows of pan de muerto *decorate family altars, in hopes of satisfying the souls who visit over the holiday. Many loaves are embedded with bread markers or small faces that are baked into the dough. The slightly sweet taste of the bread, made especially for the Day of the Dead festivities, is a treat enjoyed by the living and the dead.*

In Oaxaca, the *pan de muerto* is the same bread that is baked year-round, but with the addition of decorations. It is often accompanied by a cup of delicious Oaxacan chocolate, and it is common to tear off pieces of the bread to dunk in the hot chocolate. In Michoacán, bakeries offer both large round loaves, which often have small doll-like figures baked into them, as well as figurative breads in a variety of shapes. These are frequently hung from the large wooden frames that are traditionally placed behind the *ofrendas* in this region.

In the state of Puebla, a saltier flatbread is common. Covered with pink sugar, it is usually baked in the shape of a woman lying with her arms crossed as though in a coffin. In nearby Hidalgo, the bread is formed in the shape of human figures or hands, and sprinkled with red sugar. This variation is thought to be based on the Mexica tradition of covering the bodies of important figures in red dust when they were buried. In Mexico City, *pan de muerto* is baked in the shape of a funeral mound, with a few bumpy protrusions representing the skull and limbs poking out of the grave. Greatly anticipated by consumers, as it is available only at this time of year, *pan de muerto* also offers bakers nearly unlimited opportunities to demonstrate their artistry.

Inveterate travelers know that markets worldwide can always be relied on to provide a feast for the senses. Never is this truer than in Mexico during the Day of the Dead. While the finest examples of craftsmanship will be found elsewhere, the aesthetic appeal of the local markets is undeniable as everyone gets into the spirit of the Day of the Dead celebration.

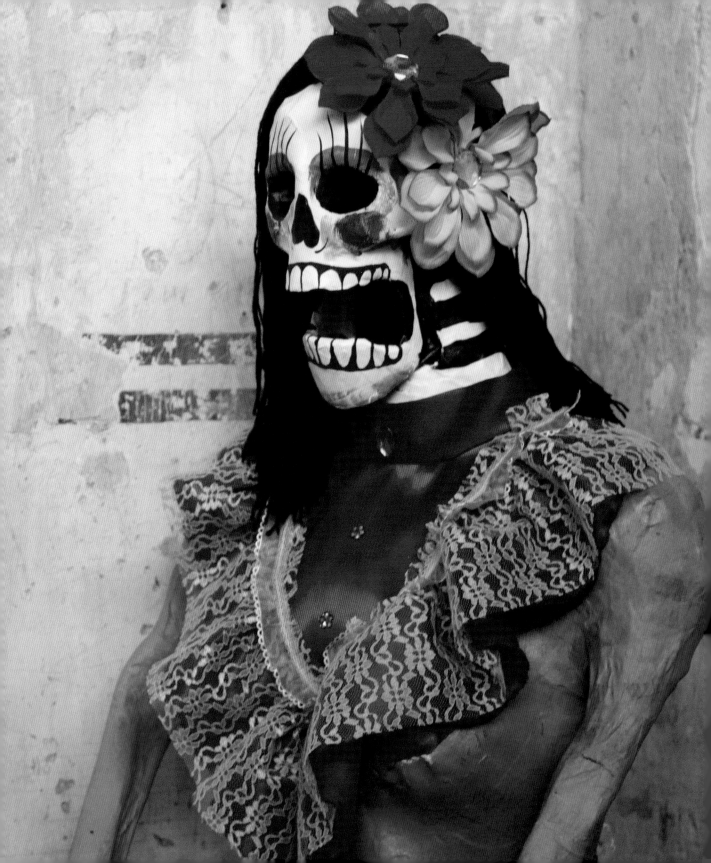

COMMUNITY ART

While at its heart the Day of the Dead is a very family-centered cele-
bration, businesses such as hotels, restaurants, and retail stores also
get into the act with elaborate installations and decorations. The Day
of the Dead festivities inspire a number of community-wide parades
and other public events as well. In both large cities and smaller
villages, contests are often held for artistic creations that may take a
variety of forms.

*The enthusiasm and effort put forth by the people living in regions such as Oaxaca,
Mexico, cannot be overstated. Evidence of their commitment to the holiday can be
seen everywhere. This figure in the corner of a small shopping plaza stands six feet
tall and is made of papier-mâché over an armature of wood and wire. The face is
expertly painted to express a very boisterous personality. Fabrics and flowers are
added embellishments.*

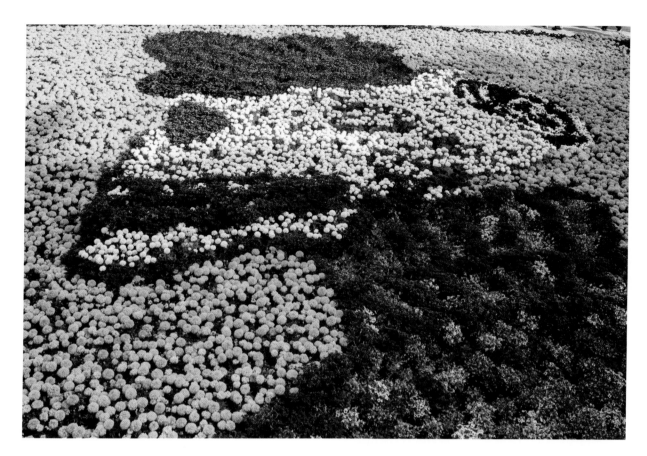

The town of Atlixco, a short distance from Puebla, Mexico, is known for the spectacular carpets made of flowers that fill the zócalo, or central plaza. Designs inspired by the Day of the Dead are created with arrangements of potted flowers. Marigolds in tones of yellow and orange predominate, while white flowers are used to create a bright contrast within the design and deep purples are used for the dark shades. Sponsored by the leaders of the city, the carpet measures about fifty meters long by ten meters wide. A ramp is constructed along the edge of the installation so that community members and visitors can view it from above.

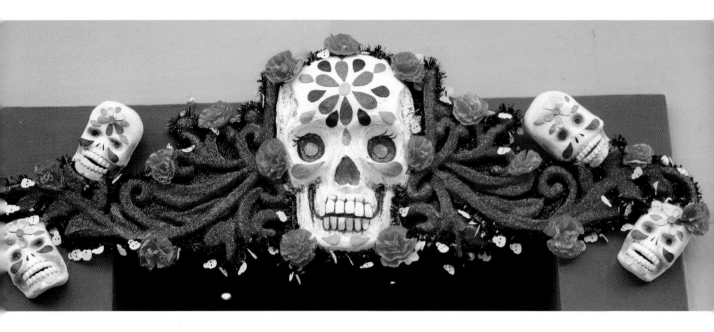

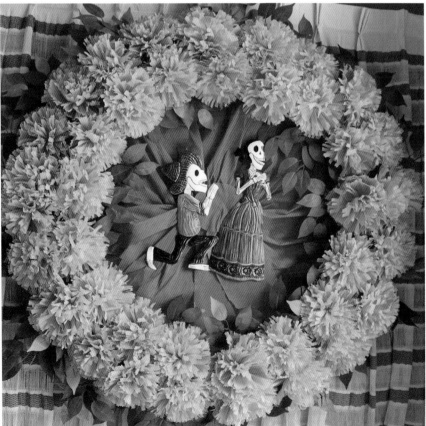

ABOVE: This stunning decoration greets visitors at the entrance of a store in Oaxaca City.

LEFT: A young couple is encircled by a wreath of tissue paper marigolds. Perhaps the young man, on bended knee, is requesting the senorita's hand in marriage. She looks away in contemplation of his proposal.

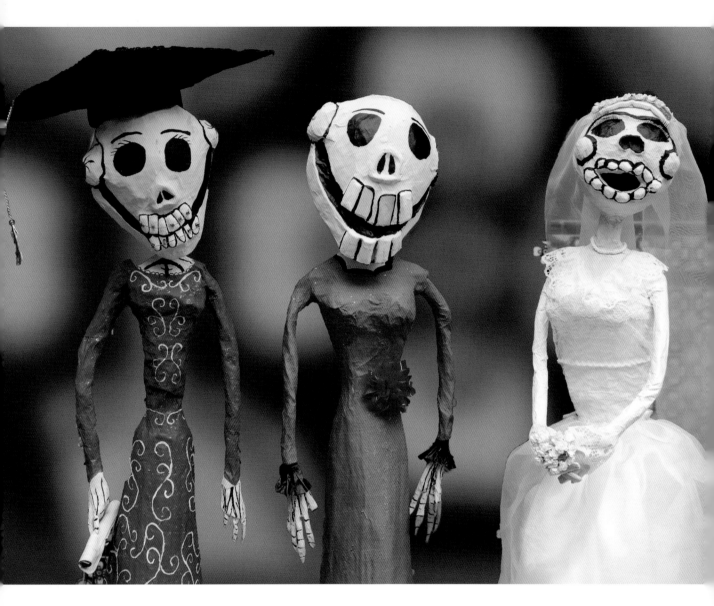

High school students in Atlixco, Puebla, Mexico, participate in art competitions for the Day of the Dead. Working in papier-mâché, also the medium of many professional artists, they create sculptures for a community exhibition. In keeping with tradition, their figures are smiling with exuberance. Using only modest materials, the students bring incredible expression to their work. Their skills in sculpting and painting deserve admiration.

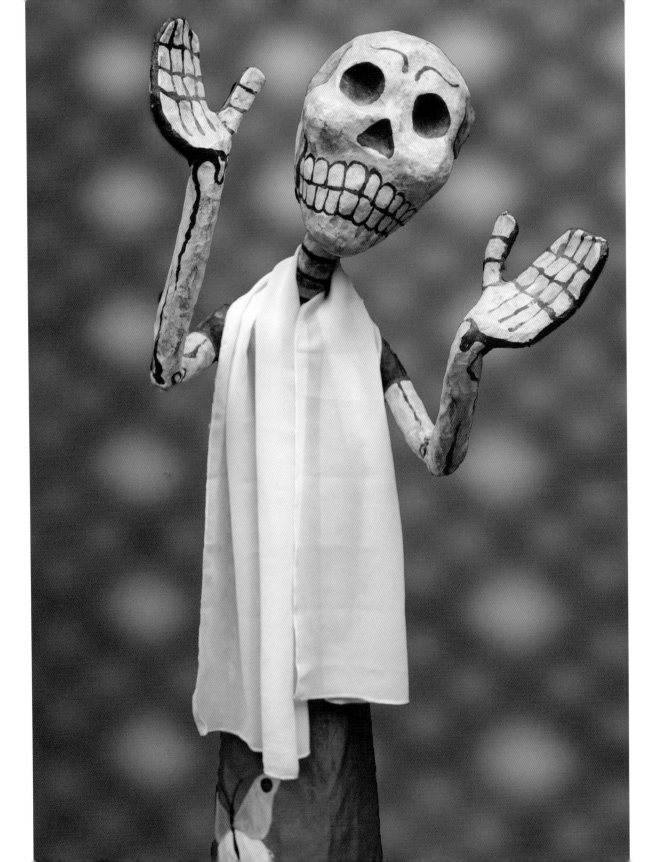

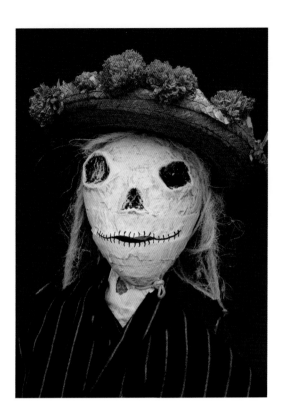

While allowing the traditional concepts of the Day of the Dead to guide their work, the high school students in Atlixco have the freedom and imagination to create unique works of art. As a result, the exhibition is a treat to attend.

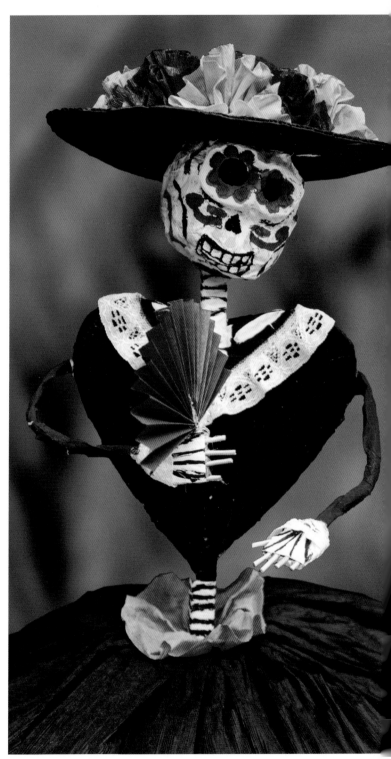

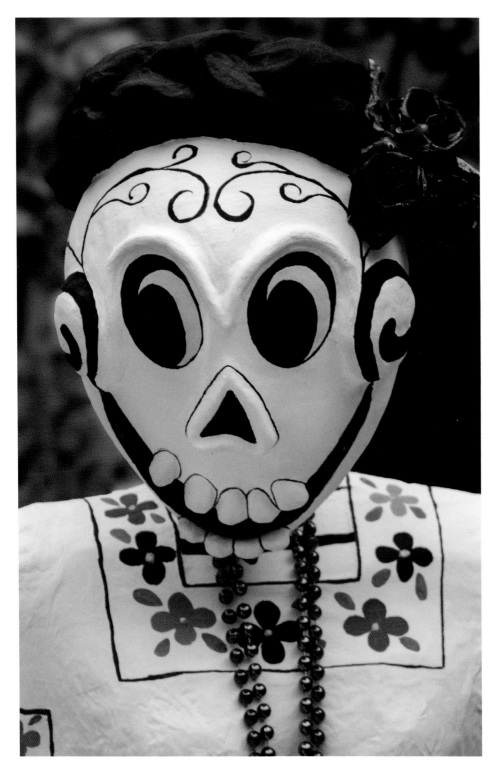

This nearly life-size student piece is a sculpture to admire. The craftsmanship is excellent and very expressive. A braid of hair encircles the face of the young woman. Deep red roses embellish her hair. The huipil, or blouse, represents a traditional style of embroidery from the region. Large, laughing eyes overlook a joyous smile that reaches from ear to ear.

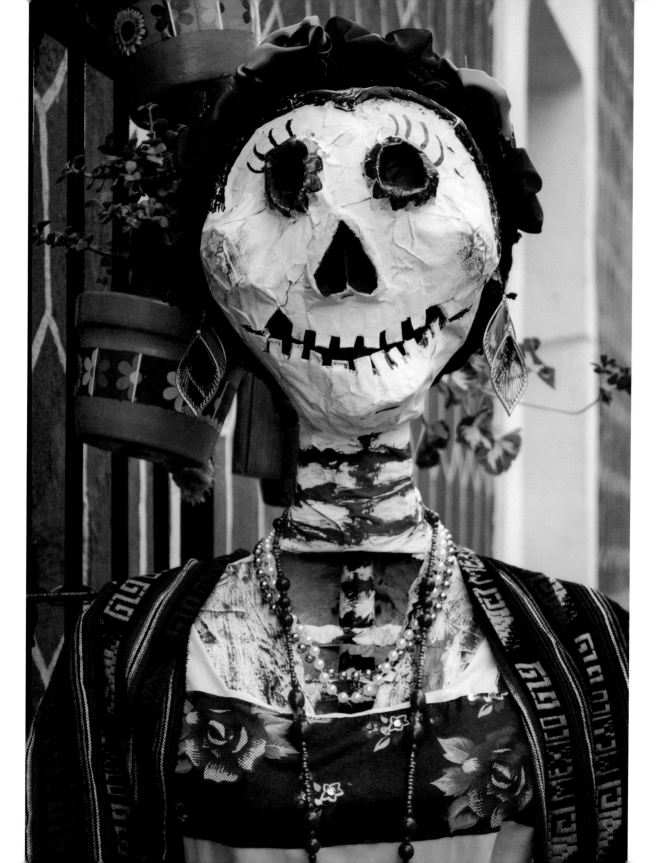

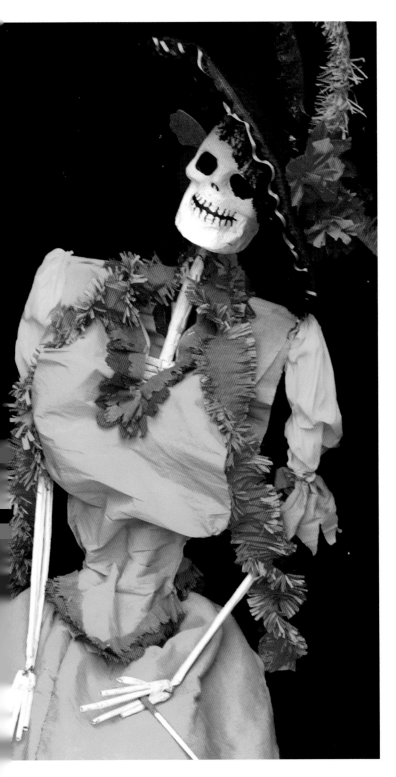

FACING: Many merchants are committed to joining in the celebrations for the Day of the Dead. This large, seven-foot figure is located in the town of Atlixco, Puebla, in front of a small business. Papier-mâché was used to create the head and shoulders of the form. A wire armature supports the rest of the body. Large, round eyes with curled eyelashes and an expansive grin invite smiles from onlookers. A shawl, woven with bright threads, covers her shoulders.

LEFT: The unique interpretations of Catrina are endless. The large hat and boa always signal her identity, but each artist has the freedom to create her image to his or her liking. A bright blue dress in contrast to a pink boa sets off this Catrina from her surroundings. The materials easily at hand determine the outcome of the final project.

BELOW: Large skeletal feet are shown extending below the cotton pants of this figure.

Ofrendas

One of the most iconic symbols of the Day of the Dead is the home altar, or *ofrenda*. While family *ofrendas* are found in virtually every home, large and elaborate ofrendas are also constructed in many public buildings in honor of public figures or other influential people.

These memorial altars usually consist of a table placed in front of a background—generally an arch or wooden frame—that has been lavishly decorated with marigolds and other flowers, as well as fruits and vegetables. In some areas, it is customary to construct the *ofrenda* with multiple levels, which are said to represent either the pyramids of pre-Hispanic times or the stages of life.

The four elements, water, fire, earth, and wind, are traditionally represented on an *ofrenda*. The returning souls are expected to be thirsty after their long journeys, so a glass of water is provided. Fire is represented by candles, at least one for each person being honored. A wide variety of fruits and vegetables symbolize the bounty of the earth. And light tissue paper banners of *papel picado* flutter in the breeze either above or in front of the table, representing the wind. Often a small dish of salt is added to purify the air. Most *ofrendas* also contain personal items that belonged to the person being honored, as well as the skull and skeleton toys, candy, and folk art that are prevalent in all aspects of the Day of the Dead festivities.

In many communities, an altar will be constructed in the central plaza or at the church

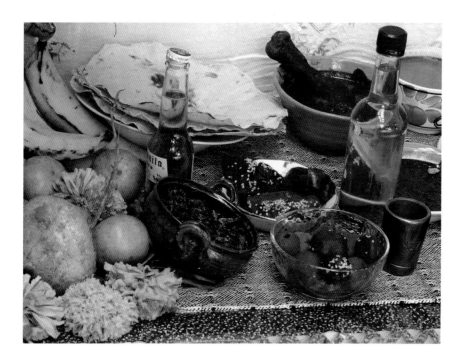

LEFT: Home altars are constructed to honor family members who have passed away. Setting the ofrenda *with special foods of the season, as well as favorites of the departed, is a way to entice the souls to return and enjoy the bounty with the living.*

FACING: This ofrenda *of the Nelson Pérez family, from Teotitlán del Valle, is artfully designed. A row of* pan de muerto *lines the front edge of the table. Fruits, vegetables, nuts, and flowers invite the deceased souls to return. An image of Our Lady of Guadalupe is the centerpiece. Teotitlán del Valle is a rug-weaving village and is home to some of the finest weavers in Oaxaca.*

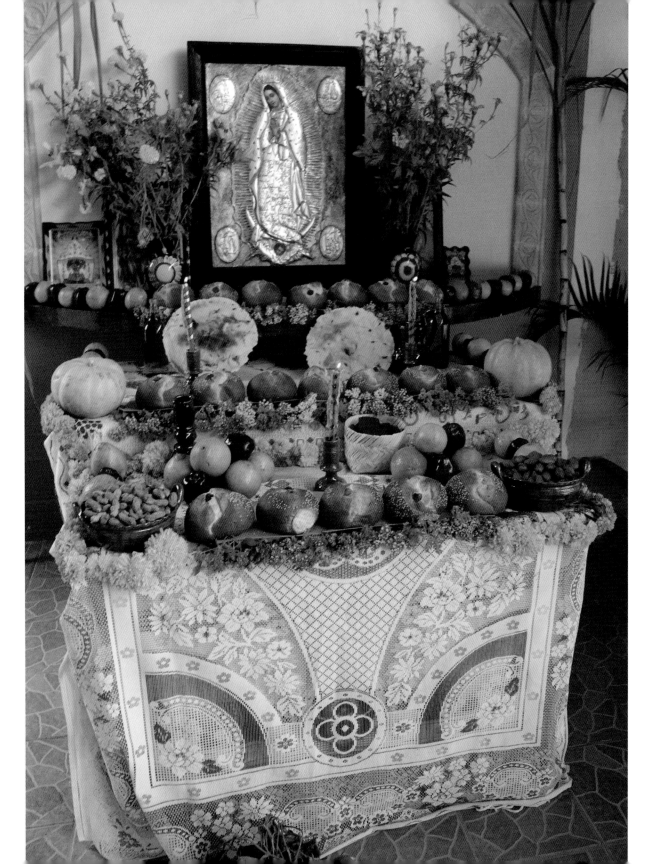

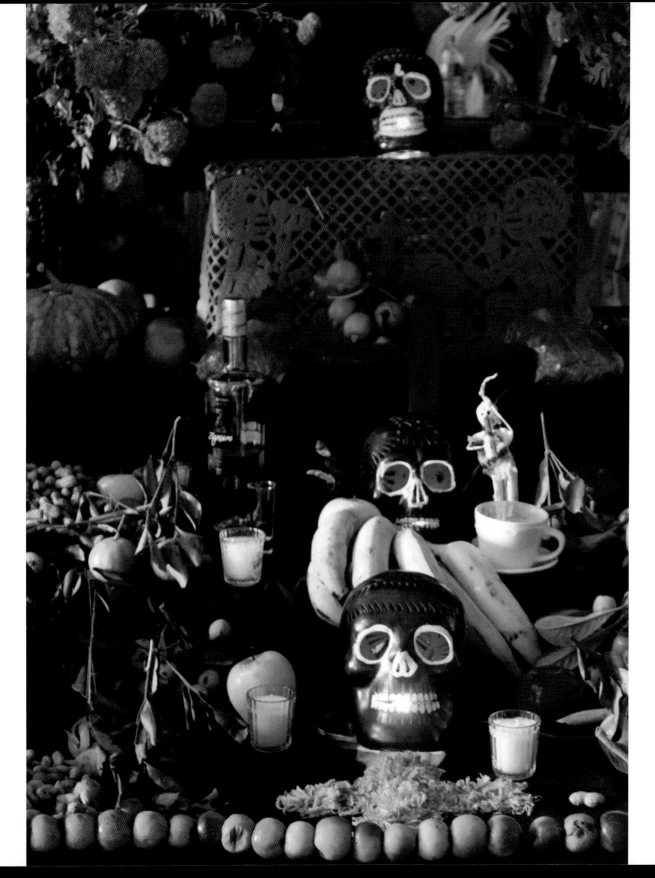

in honor of those who have no one living left to honor them. Other community altars reflect specific social problems, such as honoring victims of drug abuse or those who died of AIDS. The offerings on the *ofrendas* are always arranged with an eye for aesthetics. While the components are similar, each *ofrenda* reflects the creative talents of its makers.

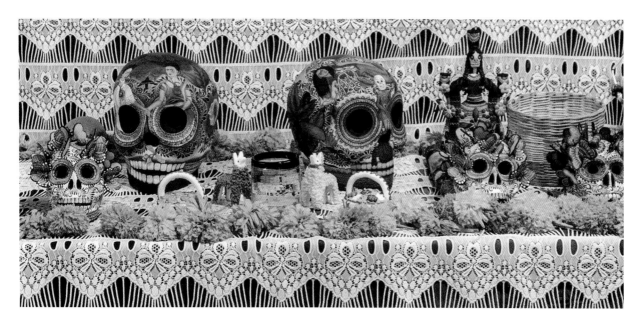

FACING: *Many public buildings, businesses, and hotels prepare* ofrendas *for the holiday, such as the one pictured here. Over the course of a few days, guests are able to enjoy watching the hotel staff construct their* ofrenda. *First the base structure is built, then the cloth and the* papel picado *are added. Finally a variety of items, including candles, skulls, fruits, vegetables, nuts, and drinks, are placed on the altar to prepare it for the souls soon to arrive.*

ABOVE AND LEFT: *Ofrendas are also found in private homes. Fruits, vegetables, and flowers are always present. Marigolds, the flowers of the dead, are commonly found in vases or used as individual design elements. The painted clay skulls featured above are part of the altar in the home of the Alfonso Castillo Orta family in Izúcar de Matamoros, Puebla, and are highly valued works.*

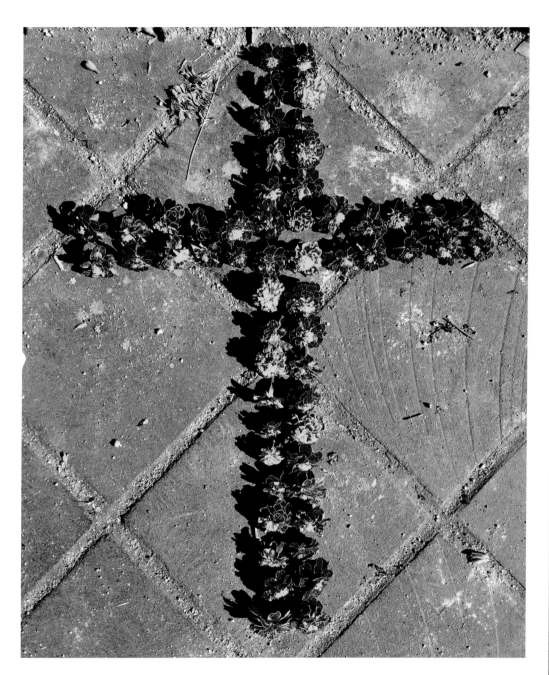

ABOVE: *Individual marigold blossoms are removed from their stems and arranged to create a cross, a simple yet elegant reminder of the role of Christianity in the celebration.*

RIGHT: *A large community* ofrenda *is dedicated to those who have lost their lives in the service of public security. Featured along the top of the* ofrenda *are photographs of those who are honored. The abundant array of flowers includes carnations, cockscomb, and marigolds.*

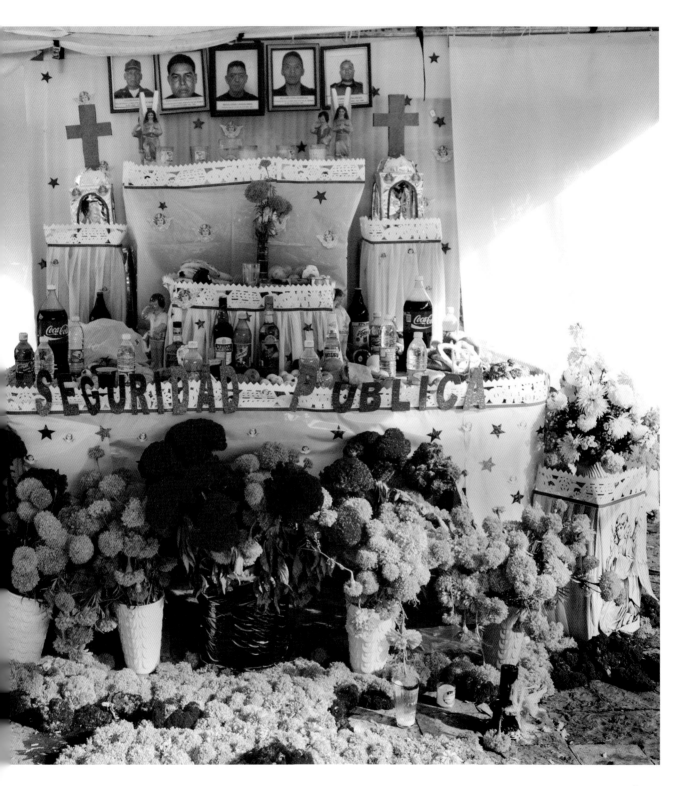

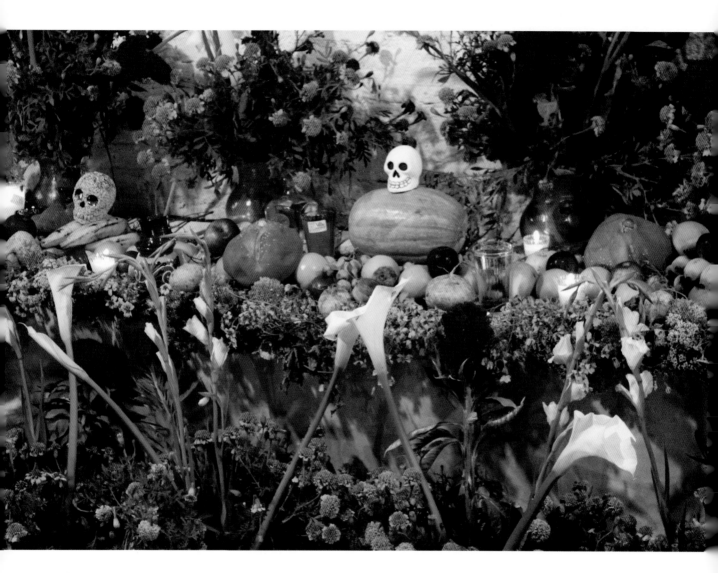

A lush and richly decorated ofrenda *is created yearly at the archaeological site of Monte Albán, located in Oaxaca, Mexico. It is dedicated to the memory of those who have contributed to the research and excavation of the site. Among those is the Mexican archaeologist Dr. Alfonso Caso, who in 1932 discovered a grave, Tomb Seven, containing a rich quantity of burial offerings. This spectacular* ofrenda *displays a profusion of fruits, vegetables, and flowers, while long-stemmed calla lilies add an elegant touch. Visitors from all over the globe are able to enjoy the* ofrenda *at this popular tourist attraction.*

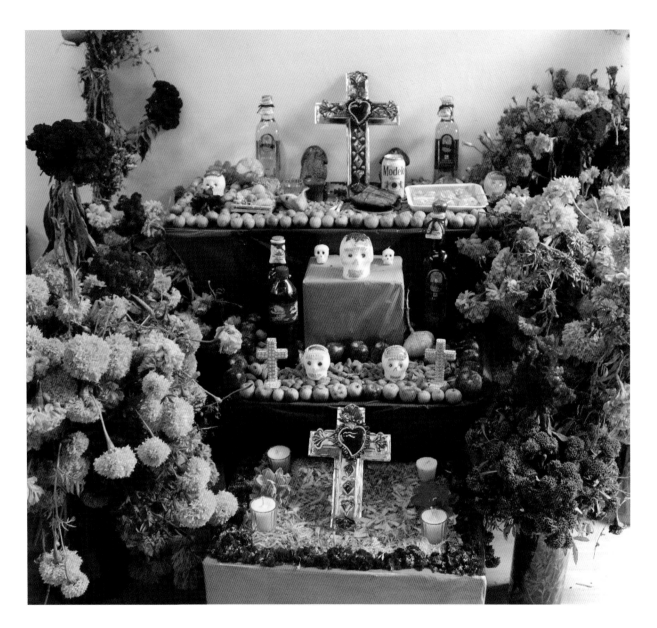

The staff at a small convenience store in Oaxaca built a lavish ofrenda *for the enjoyment of their clientele. The four-tiered structure is decorated with beautiful crosses and sugar skulls. Fruits and vegetables are used to trim the edges of two levels. Marigold blossoms are shredded to create a carpet-like covering for the bottom level. Large vases of flowers add to the drama of the presentation.*

Sand Paintings and Sculptures

Sand paintings and sculptures are another popular community art form, particularly in Oaxaca. Intricate sand paintings are often created by artists who work for hours to design elaborate images using glittery, colored sand. In the end, these artworks will be swept away, yet another symbol of life's fragility and impermanence.

On a larger scale, sand sculpture reliefs are frequently constructed in the central square, or *zócalo,* of Oaxaca City several days before the celebration. Working in brick enclosures about twelve by fifteen feet that are filled with sand, students and other groups of artists sculpt their designs, which often include skulls, skeletons, crosses, and coffins. The artisans moisten the sand with water as they work. Once the reliefs are formed, the artists use strainers to sift dried plaster in a variety of colors over the reliefs to highlight the designs. Great

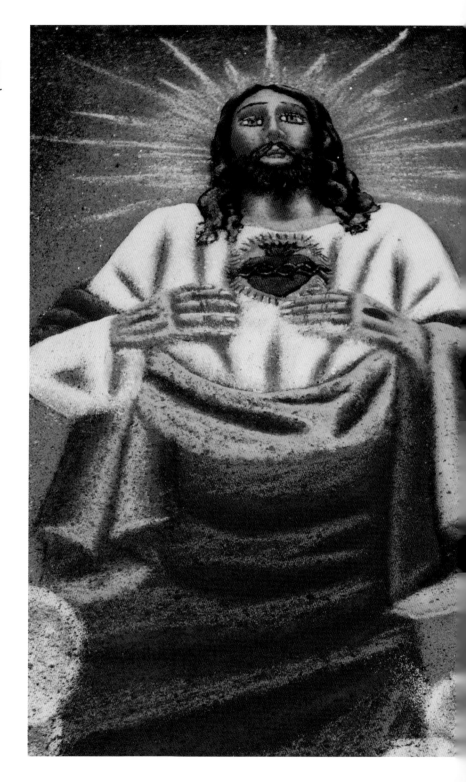

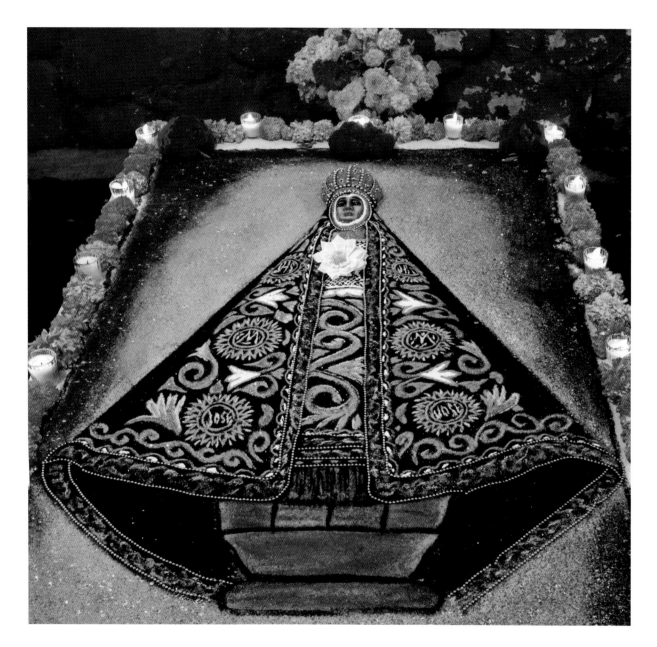

FACING: Competitions sponsored by Oaxaca City invite artists to create tapetes, or rugs, using fine colored sands. They are on display near the Panteón Viejo in Santa Cruz Xoxocotlán, Oaxaca. The Sacred Heart of Jesus figure depicted here is an example of a masterful use of colorants. As a result, the folds in his garment appear three-dimensional.

ABOVE: The Virgin of Soledad, patroness of Oaxaca City, is represented here in her black triangular robe lavishly encrusted with gold and jewels. Marigolds and candles are used to frame her likeness.

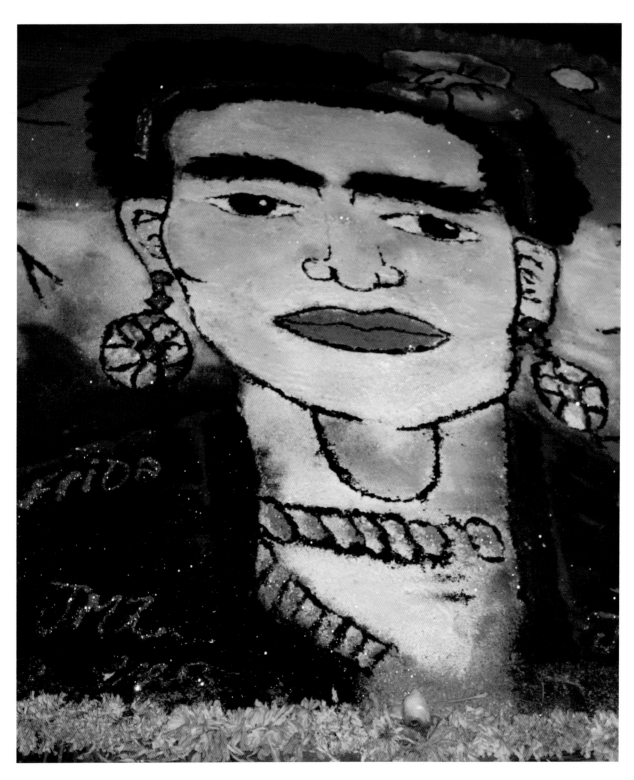

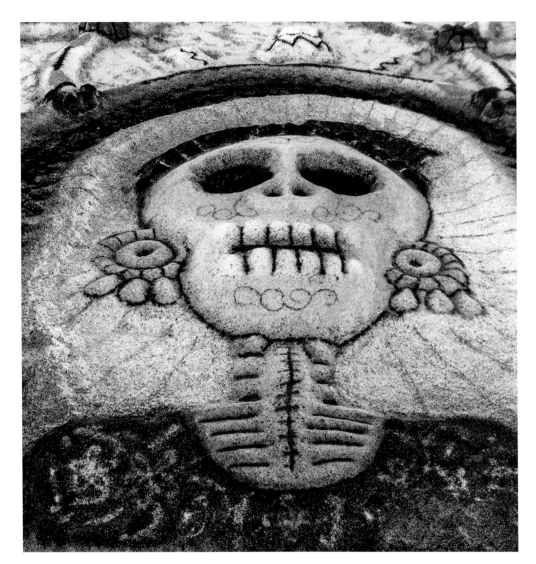

FACING: The face of Frida Kahlo is a familiar subject for many contemporary artists. Here, her portrait is created with colored sand. Always vibrant and dramatic, Frida's image pleases.

LEFT: Some artists choose to work with sand to create images with some relief. After they have sculpted the work, colorants are used to enhance the dimensionality of the design. A woman wearing large earrings and a patterned dress is depicted here in skeletal form. The soft blues and yellows suggest a calm presence.

attention is given to the skeletal forms of the figures, and the large scale of the works contributes to their dramatic impact.

These community artworks are frequently combined with competitions involving schools or other groups of artists. This generates a great deal of excitement as awards are given for most beautiful and creative designs. On at least one occasion in Oaxaca, large skulls, each about the size of a Volkswagen Beetle, filled one popular street. Similar to the famous cows of Chicago, each skull was decorated by a well-known artist or group of artists.

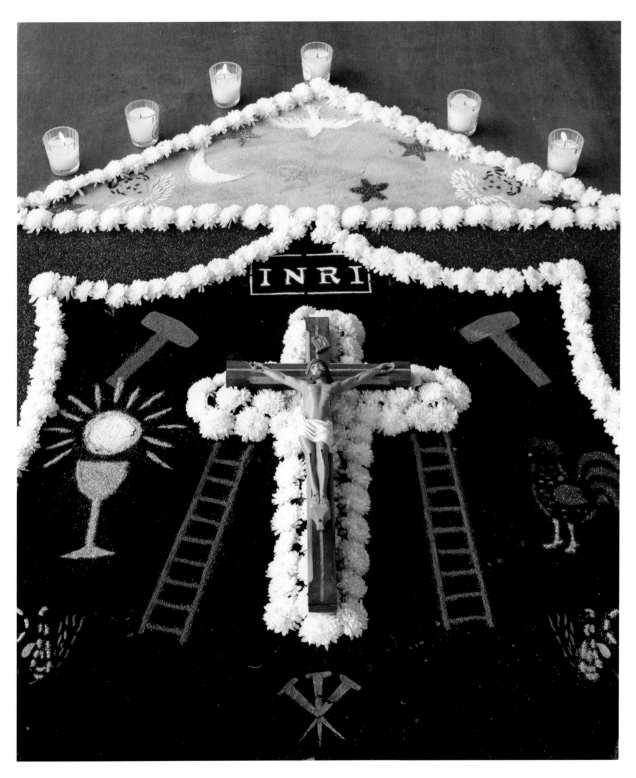

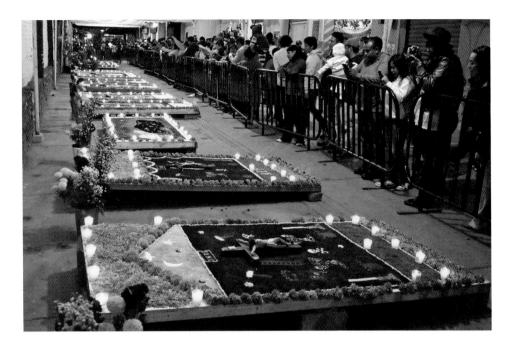

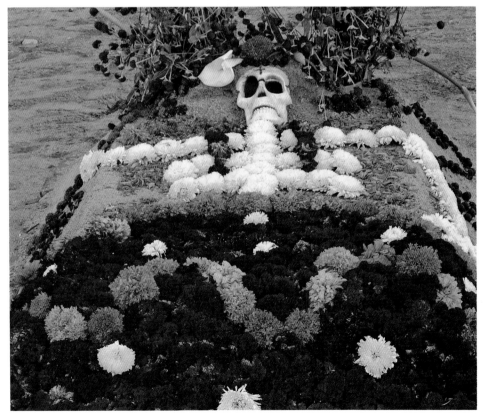

FACING: Some sand tapetes are enhanced by the use of additional materials. In this example, the crucifixion of Jesus Christ is the predominant theme. A carved wooden crucifix is added to the sand painting, surrounded by small white carnations. The flowers also trim a tent-like structure that encloses the central motif. Candles light the edge of the sand painting.

TOP LEFT: Visitors view and photograph the annual tapete competition in Santa Cruz Xoxocotlán, Oaxaca.

BOTTOM LEFT: This sand relief painting depicts a skeleton in a coffin, draped with a large quantity of orange, white, and pink flowers.

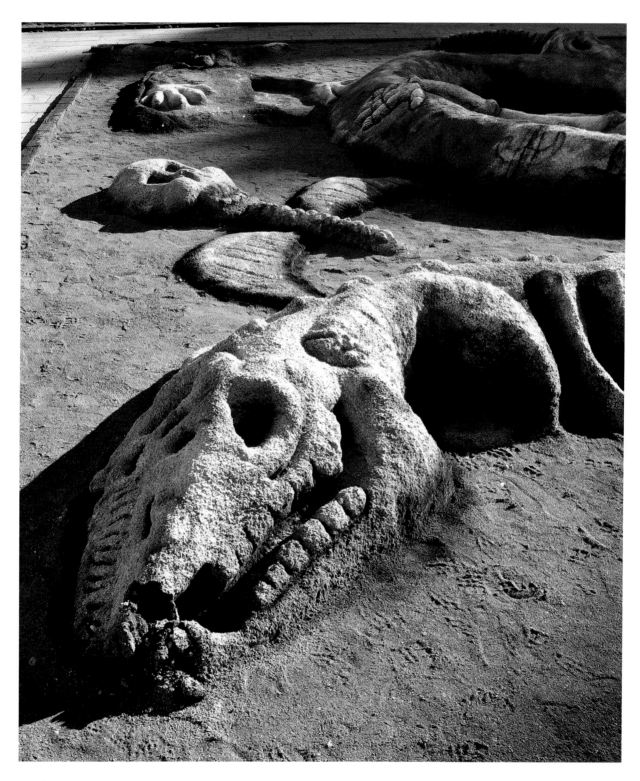

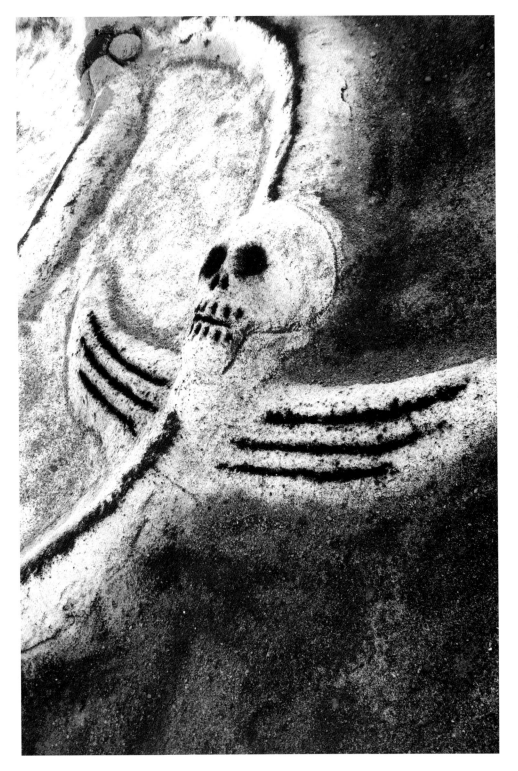

Large sand reliefs, as depicted here, are created by students from various schools. Their first task is to define large areas, fill them with sand, and trim them with bricks. Over the course of a day or so, additional sand is brought to the sites in wheelbarrows. Following a prepared sketch, students build their designs in relief. Some areas are as much as twelve inches in height. This process can take several days to complete. The final step is to decorate the reliefs with colorants. Drawing large crowds of onlookers, these competitions take place in expansive community areas like the zócalo, or central plaza, in Oaxaca City, or in large church grounds.

Parades and Pageantry

Elaborate parades and pageants in celebration of the Day of the Dead offer another opportunity for both amateur and professional artists to showcase their talents. As the Hispanic population grows in the United States, increasing numbers of celebrations are being held in American cities, particularly those close to the Mexican border such as Tucson, San Diego, and Los Angeles. In places with many Mexican residents, the festivities are often quite traditional. However, as people from other cultures become familiar with the Day of the Dead, the celebrations are evolving into more updated, intercultural events.

In these events, the participants' own bodies and faces become the canvases for elaborate artistic expression. The most common design for face painting is the skull, a tradition that grew out of a previous practice of wearing skull masks. The face painting is usually done over an opaque white background. Artists then

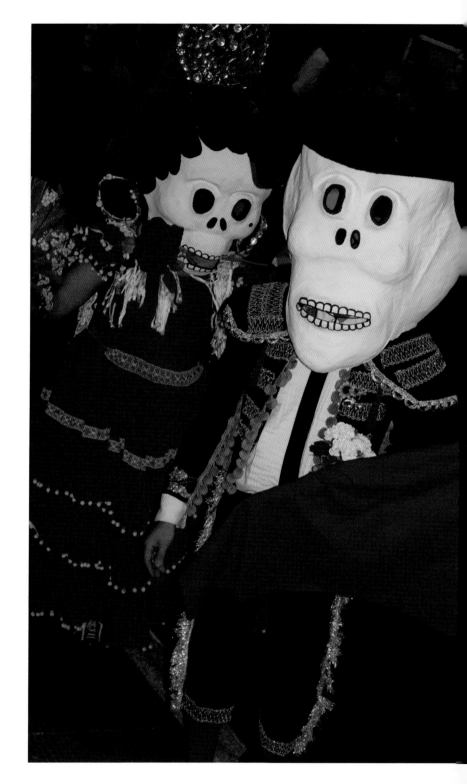

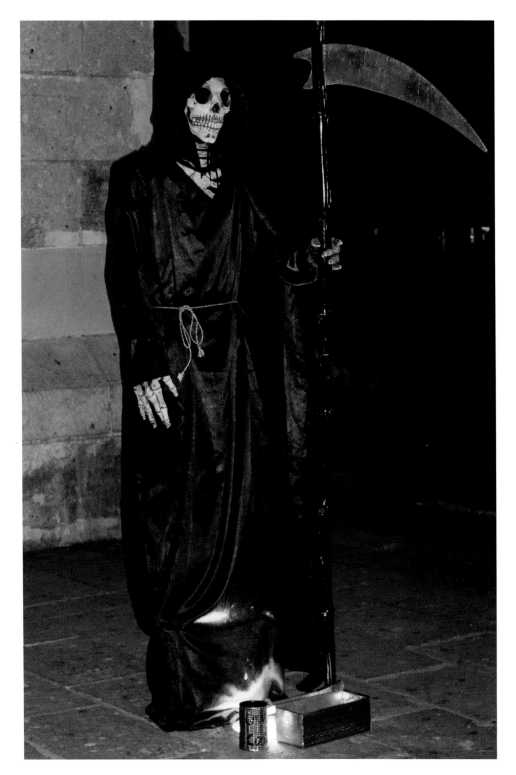

FACING: Revelers dressed as a matador and his companion wear large papier-mâché masks in an All Souls' parade in Tucson, Arizona. The streets are crowded with those walking in the parade, along with bystanders who join in the festivities. This parade is like many that occur across the United States.

LEFT: Mummers take to the streets in full costume, and invite photo opportunities for a small sum. The mummer then retrieves a note of Christian advice from the container at his feet and presents it to his customer.

Community Art ❧ 93

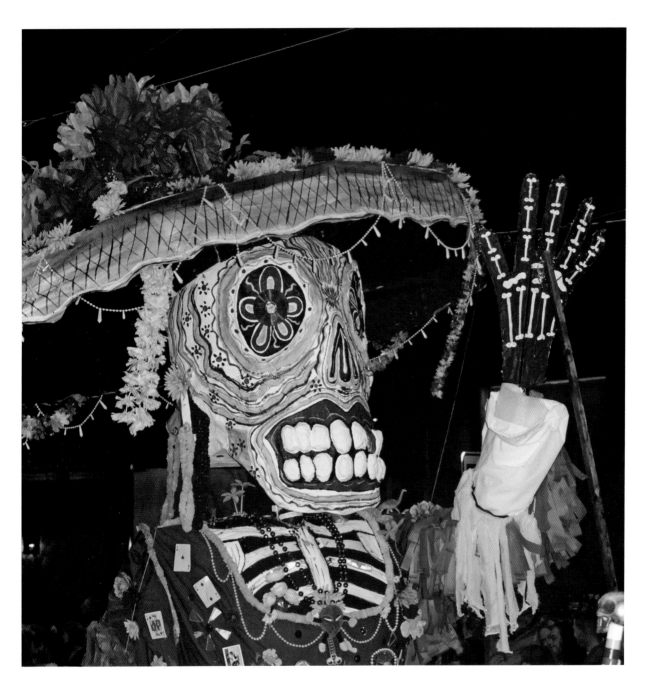

Artists in Tucson, Arizona, prepare for months to participate in the All Souls Procession, usually held the week following All Souls' Day. Elaborate masks and lavish costumes are created for the event. The influence of Catrina can be seen in the large brimmed hat worn by this participant. The costume reveals the skeletal form of the chest and hands. A large smile and pearly white teeth greet the audience.

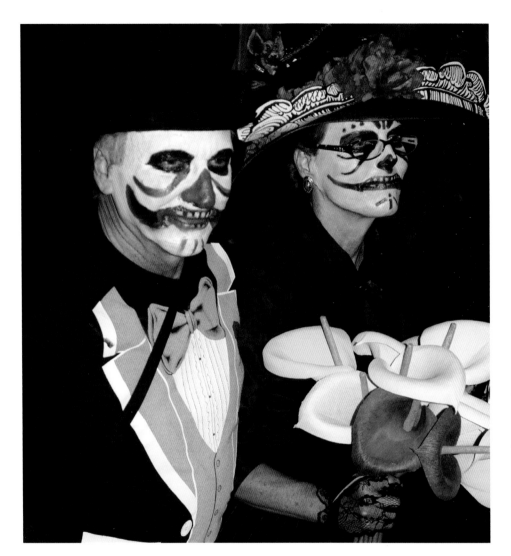

White face paint and a few simple black details transform this couple into parade participants. The woman sports a Catrina-like hat and carries a large bouquet of calla lilies. Their smiles suggest they are enjoying the event.

create stark contrast by adding deep black shading around the eyes and delineating the details around the mouth. Flowers are frequently incorporated into the designs as well, in keeping with the idea that the Day of the Dead is a celebration of both life and death. Costumes are usually flamboyant, often paying homage to Posada's famous Catrina.

Some of the most detailed and exquisite examples of this performance art are found in the participants in the vibrant processions known as *comparsas* that take place in the state of Oaxaca. Often accompanied by a band, these elaborately costumed mummers make their way through the village streets during the Day of the Dead, singing, dancing, and entertaining the spectators.

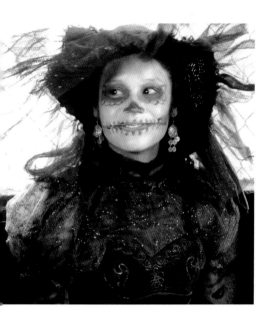

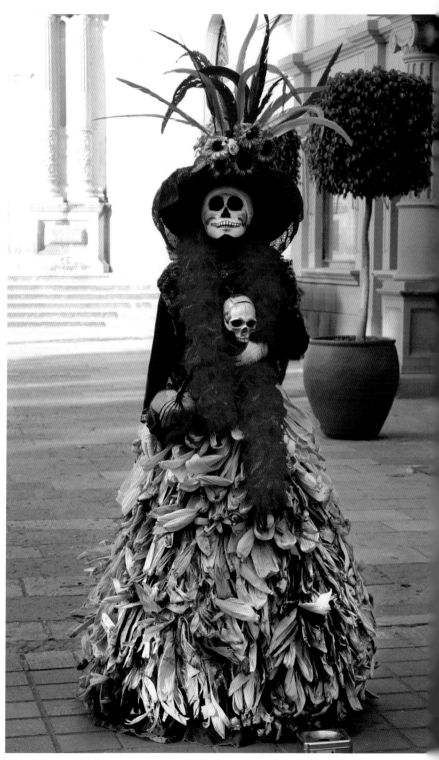

ABOVE: The beautiful daughter of Enedina Vasquez, a clay artist from Santa María Atzómpa, greets a group of visitors at her home wearing face paint and a costume.

RIGHT AND FACING: The image of corn, a staple in the Mexican diet, is often present in Mexican art. The skull as a decorative element has its origins in the preconquest era before the arrival of the Spanish. Together they symbolize the journey from life to death. These two female mummers are dressed in costumes that carry important cultural meaning. Skirts made of dried cornhusks and decorated with skulls evoke the beliefs underlying the traditions of the Day of the Dead. Their large hats, decorated with ample flowers and feathers, are inspired by the ever-present essence of Catrina.

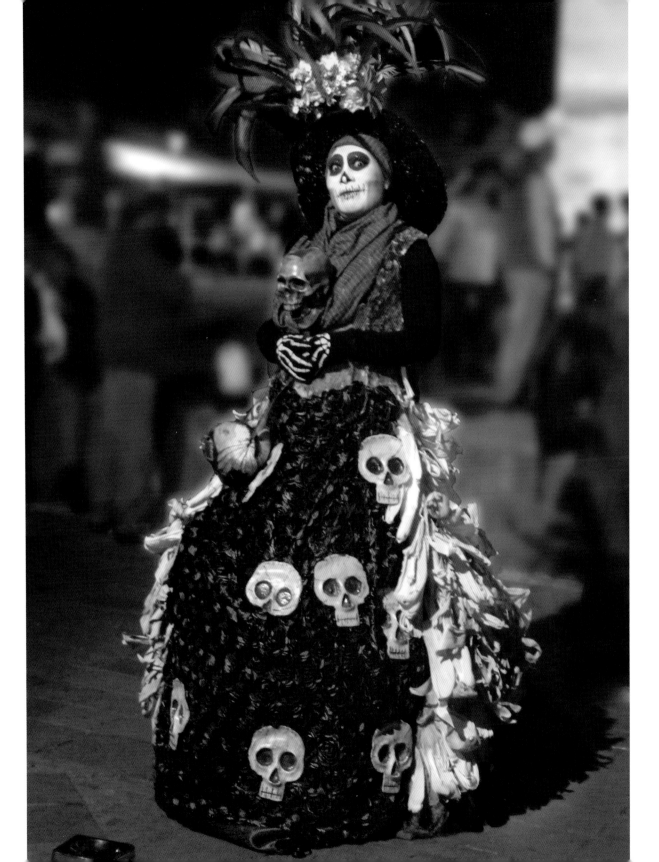

Monos de Calenda

On an even larger scale are the gigantic papier-mâché puppets known as *monos de calenda* or *mojigangas.* For over one hundred years, these puppets have been an important part of religious festivities, and often make an appearance for the Day of the Dead. Accompanied by the music of a band, the *monos de calenda* dance and entertain the crowds at parties and other public events.

The puppets are constructed with frames of reed or bamboo, and topped with large papier-mâché heads with hair and painted features. Artists work for a month or more to create a *mono de calenda,* depending on the weather and how long it takes to dry at each stage of the construction. There is great demand for the puppets, which are rented by the day. Depending on the type of fiesta, people will request specific figures. A man and woman are common, but for weddings it may be a bride and groom, and for the Day of the Dead, Catrinas and devil figures.

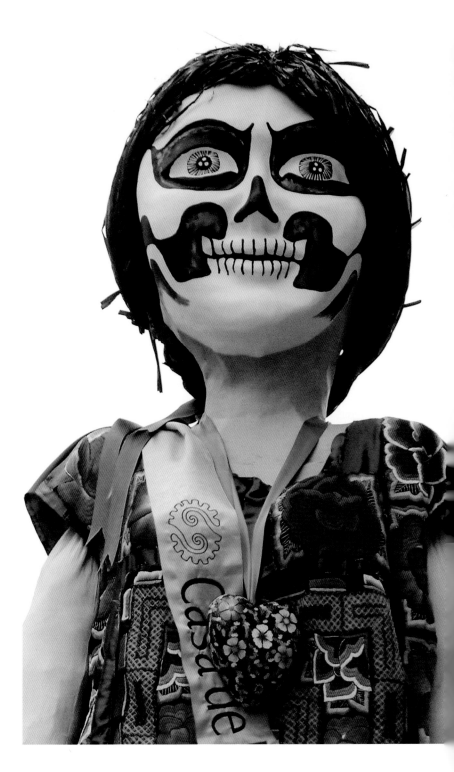

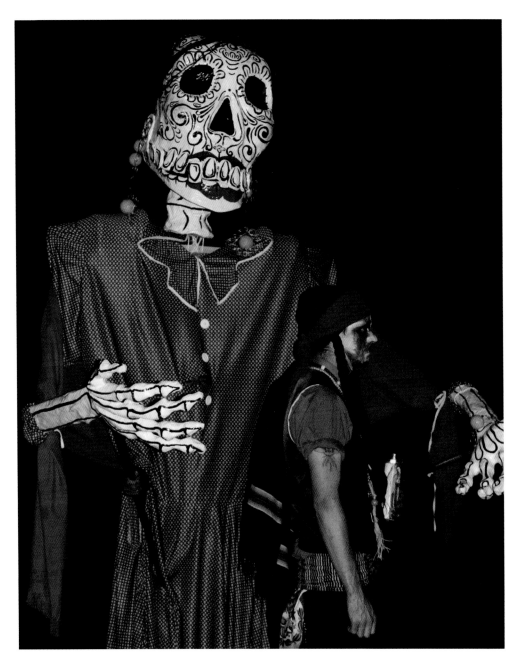

FACING: Monos de calenda *are often seen outside of folk art and craft shops to help advertise their location, until they are needed for a parade or event. With a dramatically painted skeletal design on her face, this piece is ready for Day of the Dead festivities. She is wearing a traditional* huipil, *or blouse, and a large wooden heart adorns her neckline.*

LEFT: *Parades are a common occurrence during the Day of the Dead holiday. People of all ages dressed in costumes fill the streets. This* mono de calenda *has several people guiding the person inside the costume. Its large arms are operated with long rods, so the figure has a greater range of movement, and consequently makes a more dramatic effect.*

Cemetery Vigils

While a great deal of artistic expression goes into the preliminary festivities, the real heart of the Day of the Dead celebration occurs at the cemeteries. In the days and weeks leading up to the cemetery vigil, families work together to clean and repair the graves of deceased family members. Then the decorating begins.

Once again, the marigold figures prominently, although there are variations depending on the region. In the state of Michoacán, the graves are built up every year with fresh mounds of mud, which are then blanketed with marigold petals. In other areas, the entire blossom is utilized, along with additional flowers—often brilliant magenta cockscomb and baby's breath. Sometimes the flowers are put in large vases or coffee cans, or simply placed around or on top of the grave. Candles, sugar skulls, skeleton figures, candles, and the traditional *pan de muerto* are frequently incorporated as well.

There are also stylistic variations by cemetery. At one small graveyard in Michoacán, long taper candles are used almost exclusively, creating a beautiful and elegant look. In other places, unofficial competitions appear to have sprung up, with families competing to see who can create the most lavish and creative grave decorations. One memorable grave boasted a full-sized bicycle created almost entirely of marigolds.

Individual grave decorations may be simple or ornate, but are always an expression of the love the family feels for its deceased. Taken as a whole, a visit to the cemetery during the Day of the Dead is nothing short of spellbinding.

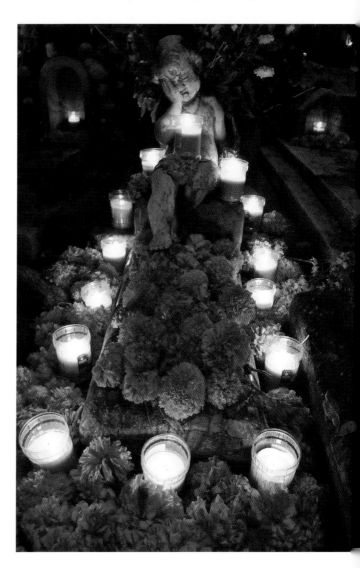

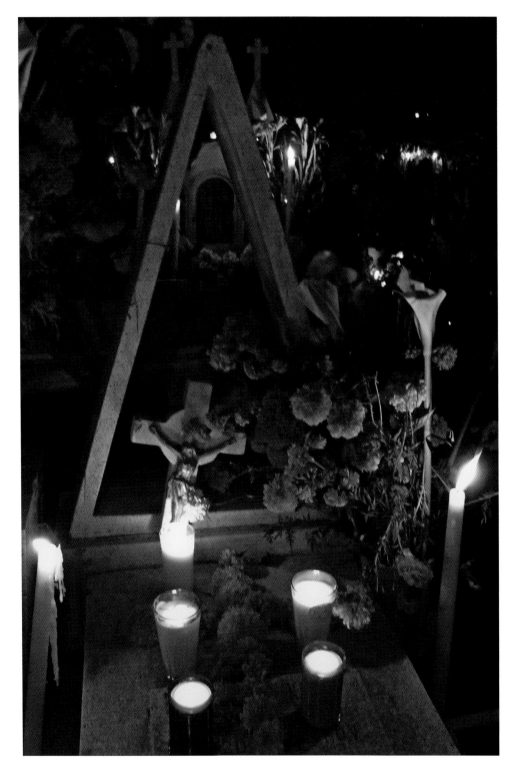

The town of Santa Cruz Xoxocotlán, commonly called "Xoxo" by locals (pronounced "Ho ho"), is located outside of Oaxaca City. It is a great destination for visiting the all-night vigils held on October 31 because it has two cemeteries, Panteón Viejo (old cemetery) and Panteón Nuevo (new cemetery). Gravesites are designed by family members, and represent the wishes and beliefs of the deceased. Lighted candles surround a lavish display of large marigolds on a grave in Panteón Viejo (facing). A stone figure is seated at the head of the gravestone. At Panteón Nuevo (left), a dramatic pointed arch defines the head of this grave with simple but elegant decorations. Long taper candles and calla lilies are placed on the sides and marigolds are used in profusion around the site.

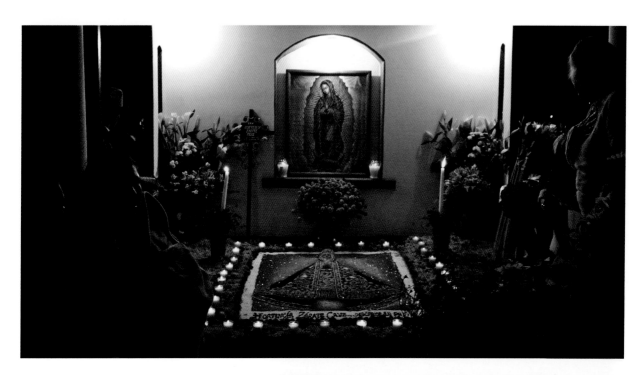

ABOVE: Family members invested a great deal of time and expense to create this beautiful resting place for relatives, one of the largest gravesites in Panteón Nuevo. A framed picture of Our Lady of Guadalupe hangs on the wall, and a massive bouquet of marigolds rests at her feet. On the ground, the Virgin of Soledad, the patroness of Oaxaca City, is depicted in a sand painting. Rows of flowers and candles surround her image. Family members are seated in the area, and welcome visitors to admire their work.

RIGHT: Some graves have very simple decorations, as in this example where the entire grave is covered with marigold blossoms. The lighted cross, made with candles, illuminates the skull in the center.

FACING: Some families have the means to provide more elaborate gravestones. A large crucifix mounted on a pedestal enhances this three-tiered example. Large vases on either side hold bountiful bouquets of flowers. A cross, covered with marigolds, sits below the crucifix. Lighted candles trim the edges of the top tier.

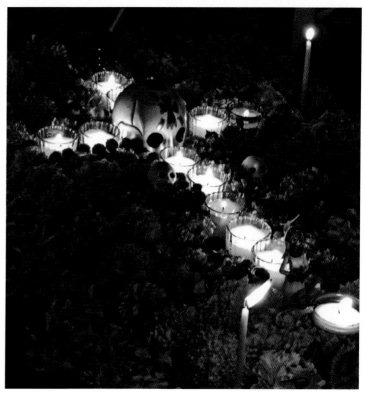

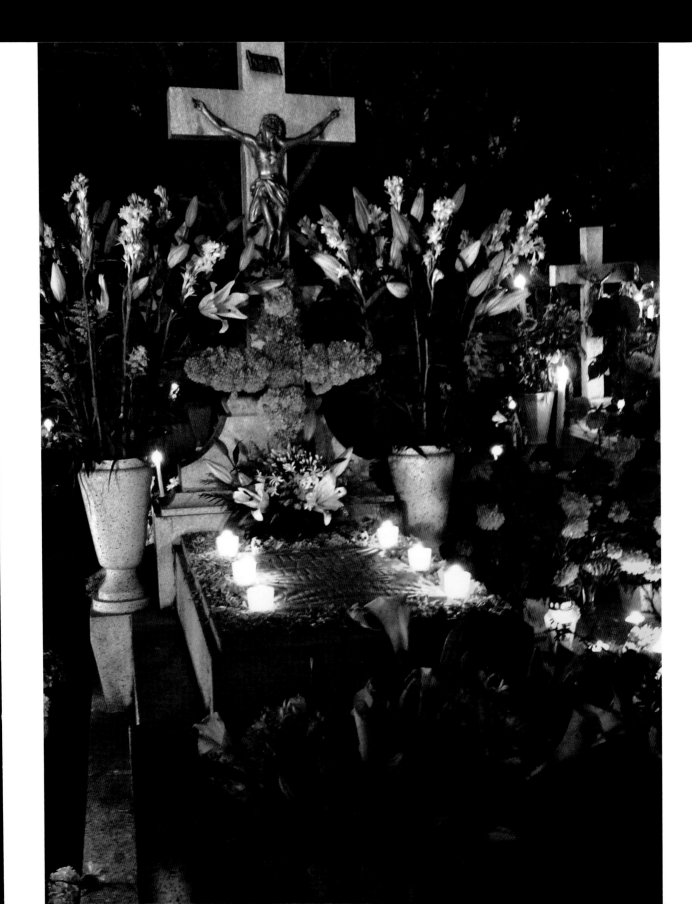

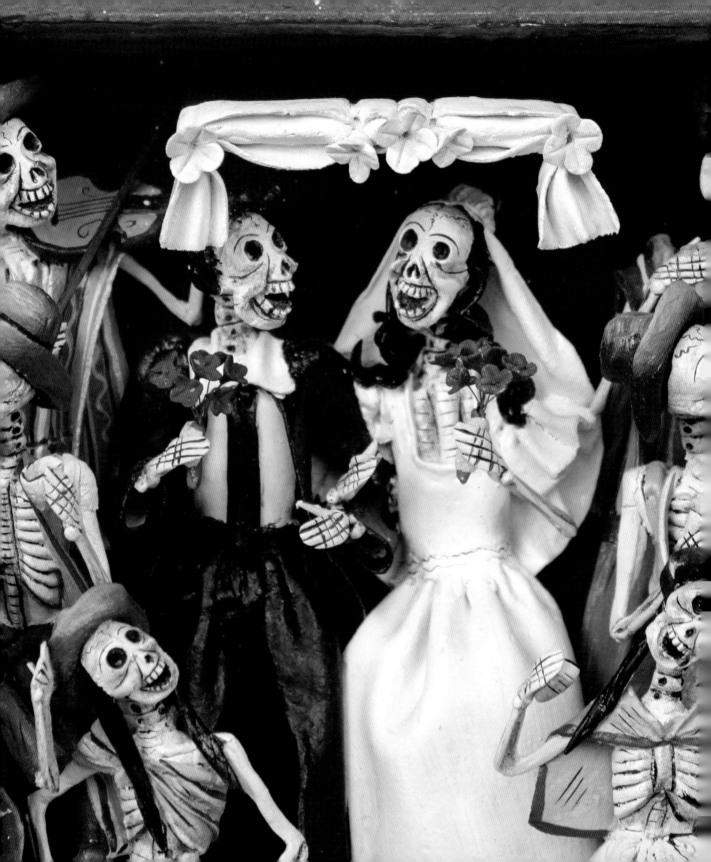

CONTEMPORARY EXPRESSIONS

The riot of colors and spectacular imagery found in the Day of the Dead celebration offer unparalleled opportunities for creative expression. Artistic displays are seen everywhere, from the home *ofrendas* and lavishly decorated graves to the large-scale installations at hotels and businesses and public works of art. But while the spirit of creativity infuses nearly everyone in their personal celebrations of the holiday, there are some artists who, through their originality, imagination, and skill, have excelled and hold a special place in the arena of Day of the Dead art. Inspired by the themes and imagery of the celebration, these fine artists use the tools and media of their respective traditions to create fine pieces that are sought by collectors, galleries, and museums around the world.

The joyous occasion of a wedding is often captured in Day of the Dead folk art. Luis and Julia Huamani Rodriguez from Ayacucho, Peru, sculpted this piece. Three-dimensional figures of the bride, groom, and wedding party are formed from a paste made of boiled potatoes mixed with gypsum. The white banner over the couple's heads appears as supple as fabric. Everyone is dressed in their finest for this festive occasion.

As the Day of the Dead becomes more popular and its influences extend beyond the borders of Latin American countries, artists everywhere are finding a growing audience with an appreciation for Day of the Dead–themed works. As a result, contemporary artists outside of the traditional cultures are increasingly exploring and reworking the imagery with their own unique visions. In this way, demand in the marketplace informs the artist and vice versa in an ever-widening circular process of creation.

Whether traditional or contemporary, the works of these artists help us all to appreciate not only the beauty, but the significance, of the fascinating celebration of the Day of the Dead.

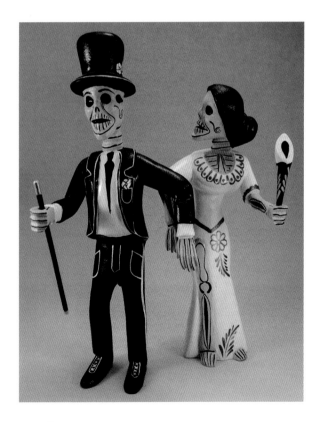

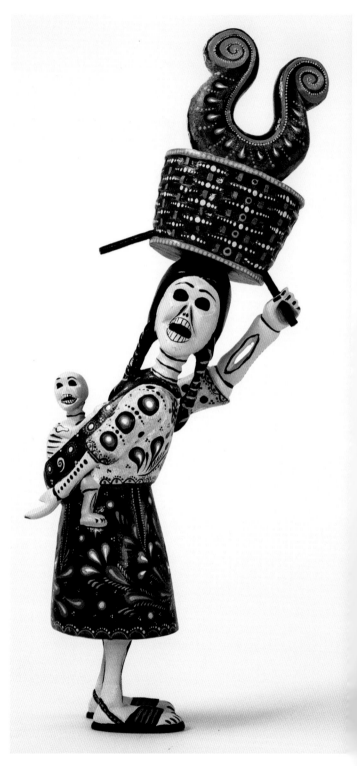

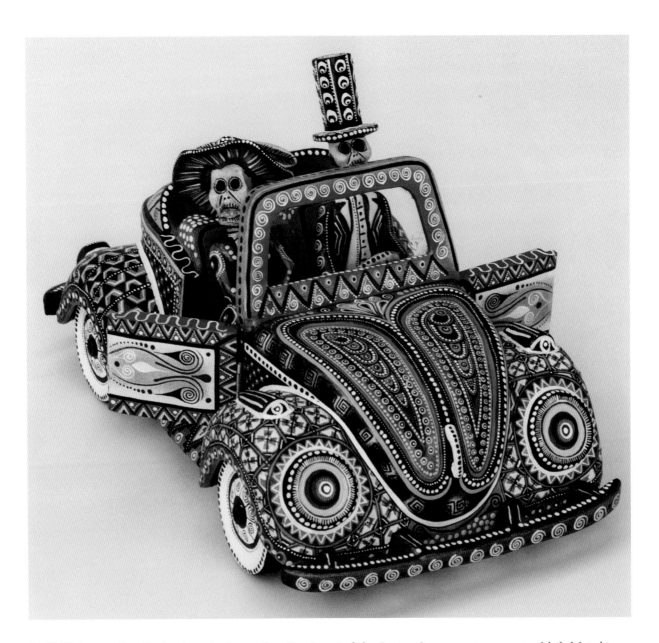

FACING: Agustín Cruz Prudencio, a woodcarver from San Agustín de las Juntas, Oaxaca, captures events of daily life in his work. The bridal couple (left) is a very popular subject for the Day of the Dead, promising a love so enduring it will last through all eternity. A young woman with her child on her back (right) walks to the market with a large basket on her head. Agustín's wife, Carmen Sosa Ojeda, painted the intricate details on his figures.

ABOVE: Manuel Cruz Prudencio, also from San Agustín de las Juntas, carved Catrina and her male companion seated in their Volkswagen convertible. A machete and various knives were used to complete the carving of the piece. Several grades of sandpaper, from coarse to very fine, were used to prepare a smooth surface suitable for painting. The fine details were then painted with small brushes, sometimes made with a single strand. Manuel's wife, Ruvi Martínez Fabian, designed and painted the patterns on this piece.

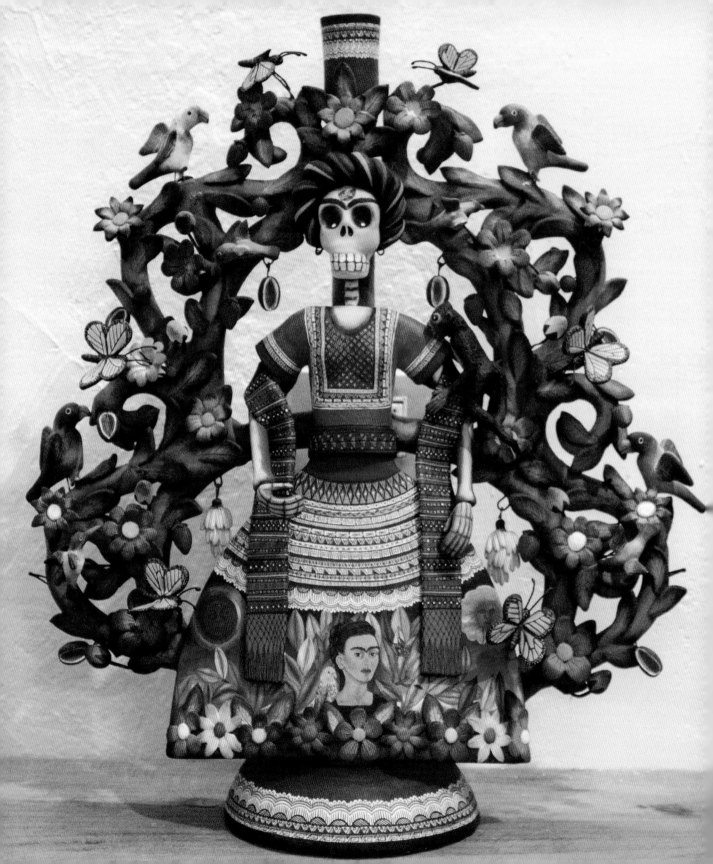

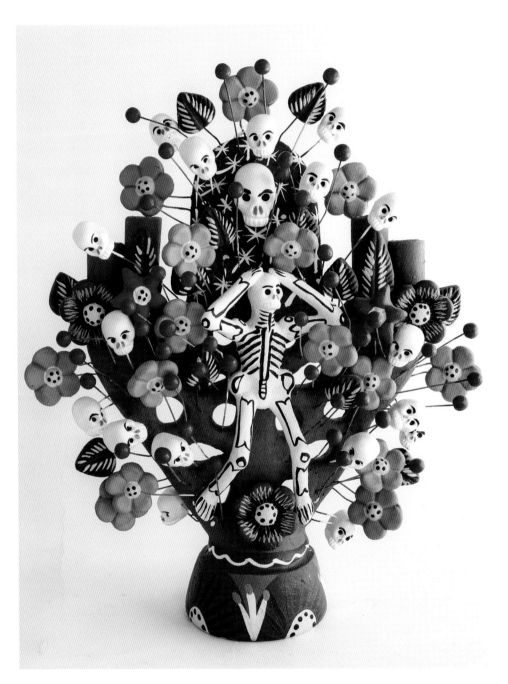

FACING: The distinctive style of the Alfonso Castillo Orta family from Izúcar de Matamoros, Puebla, is evident in this wonderful candelabra. At the center of the form is the figure of Frida Kahlo, a famous Mexican painter. She is depicted wearing a traditional huipil, or blouse, and an ornately patterned skirt. Her face is presented in both life and in death: the figure has the face of her skeleton and her skirt has a painted image of her as she appeared in life. Frida was known for her love of animals, especially birds and monkeys, and they were often depicted in her self-portraits. A monkey rests near her shoulder and many birds and butterflies alight in the tree that surrounds her. Brightly colored flowers trim her skirt and adorn the tree.

LEFT: The central theme of this clay tree of life, in the form of a candelabra, is the large skeleton attached to the front. Additional skulls, brightly painted flowers, and leaves complete the piece. Incised designs encircle the base of the work and add to its decorative quality. Created in Metepec, Hidalgo, Mexico, pieces like this are often not signed by an artist because they represent the combined efforts of several family members.

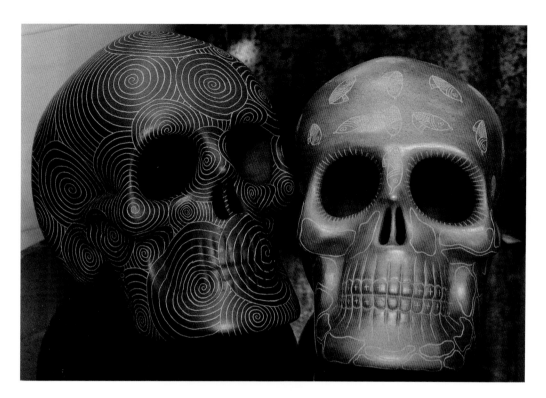

In Mexico, the importance of the skull as a subject of art cannot be overstated. Originating during the preconquest era, the image carries significant cultural meaning.

ABOVE: Néstor Omar Hernández Santiago, a young clay artist from San Juan Bautista Guelache, Oaxaca, has embraced the theme with enthusiasm. His elegant, finely crafted forms are polished and embellished with repeating patterns of swirls made with natural colorants.

RIGHT: Clay skulls created by Alfonso Castillo Orta, from Izúcar de Matamoros, Puebla, are constructed with clay and then fired. The details are added with paints and very fine brushes. A full palette of rich colors is used to paint repeating patterns and leaf-like designs inspired by nature. In this example, small, blooming barrel cacti and scorpions are added to enhance the piece.

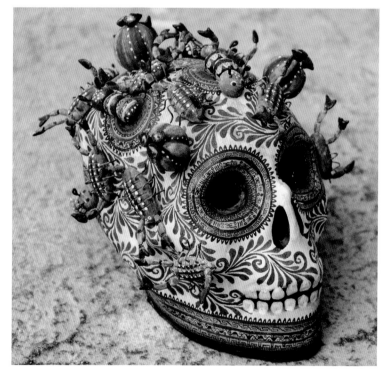

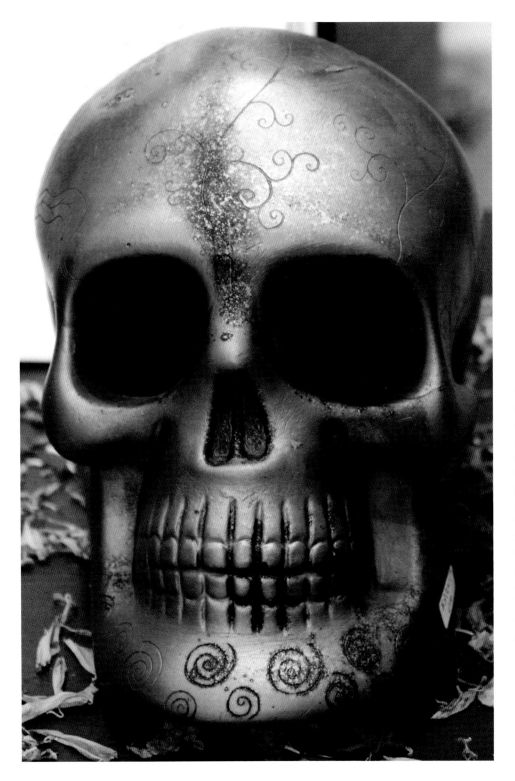

This larger-than-life-size skull by Néstor Omar Hernández Santiago, from San Juan Bautista Guelache, Oaxaca, is a testament to his growing body of work. The swirls were incised or carved into the clay when it was still moist. The surface of the skull suggests it was fired in an earthen kiln underground. The gunmetal black finish is achieved by placing the piece in a reduction firing. When all of the oxygen is reduced from the firing, the clay turns black.

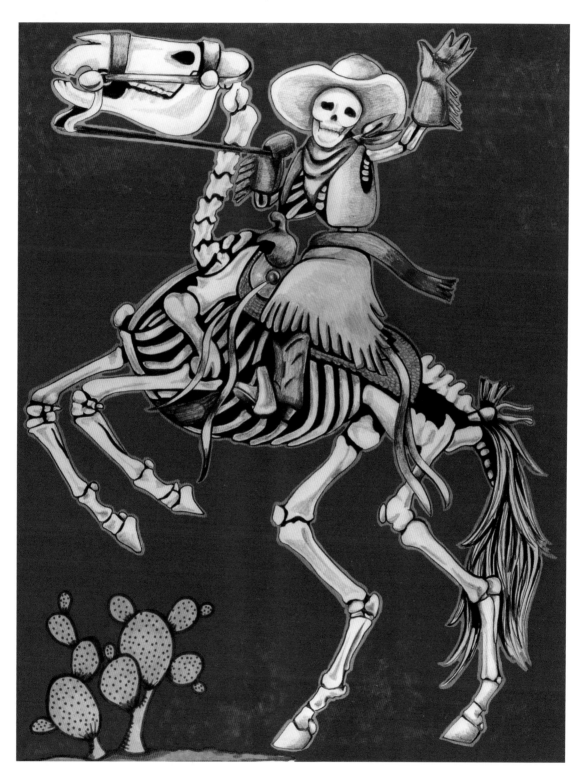

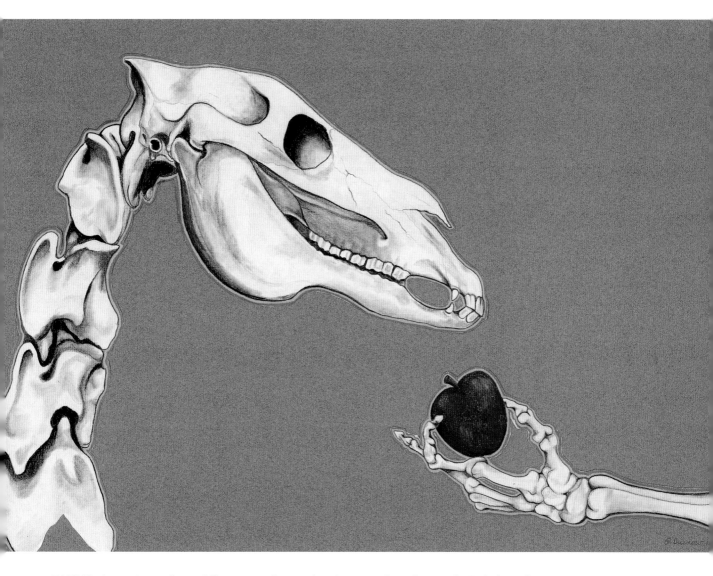

FACING: A young cowgirl gracefully waves to the crowd as she moves through a parade. Both she and her equine companion are in skeletal form. Aptly titled Cowgirl, *this piece began as a black-and-white pen and ink drawing, with color added in the background. The artist, Robyn Duenow, resides in Chicago and Tucson, Arizona. Her love of horses came through her father, who died when she was young. This profound loss led Duenow to seek solace in their shared love of equine friends. The depiction of horses in her art has served as a means of healing, as well as a tribute to her father since his passing.*

ABOVE: Apple a Day *by Robyn Duenow, an 18 by 26 inch graphite and ink drawing, explores the concept of the journey between life and death. The apple represents man's seduction of the equine species to jump, run, plow, and fight for the benefit of humankind. It is also a life-giving food, an image in direct contrast to the skeletal frame of the horse. By embracing the image of the skeleton, Duenow honors the connection between man and horse for all eternity.*

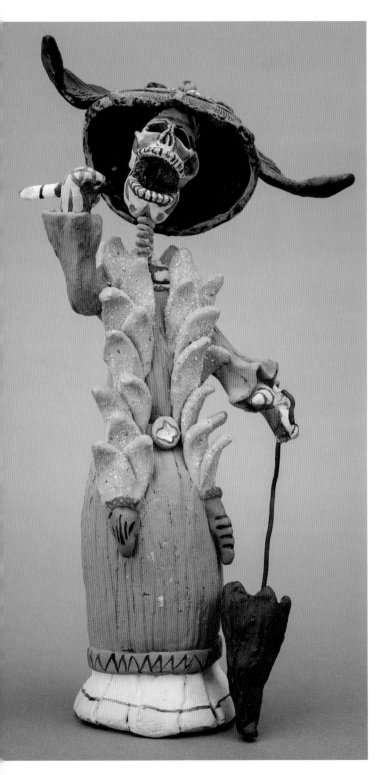
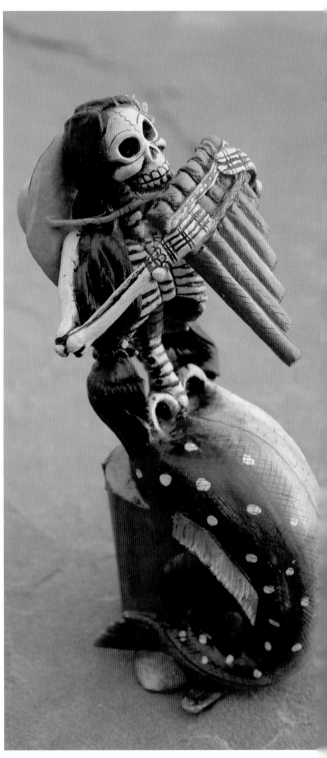

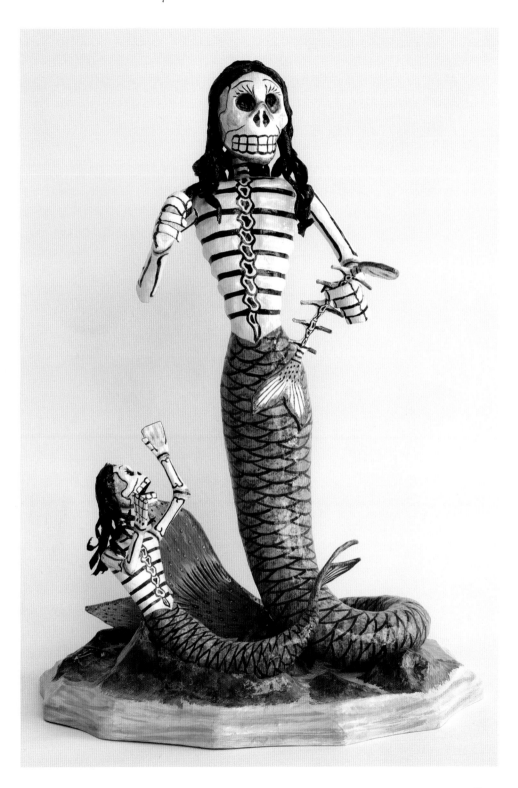

FACING, LEFT: Catrina, smiling widely, emerged from the capable hands of artist Josefina Aguilar from Ocotlán de Morelos, Oaxaca. Matriarch of a large family, she guides the production of the Aguilar family clay sculptures. Taught by her mother as a child, Josefina has become one of the most honored and recognized clay artists in Mexico. Many of her works reside in the finest folk art museums. To create the work, the family processes their own clay, builds the figures, and fires the pieces at their home studio.

FACING, RIGHT: An exquisite mermaid plays a pan flute to entertain her audience. She was crafted by a member of the Alfonso Castillo Orta family, from Izúcar de Matamoros, Puebla. Her delicate clay form balances perfectly, while her wide grin assures us that she enjoys playing music.

LEFT: Mermaids are a recurring theme in Day of the Dead art. A mother and her daughter are depicted here, after enjoying a tasty meal together. Their skeletal frames are contrasted by bright colors of orange and pink. The artist, Joel Garcia from Mexico City, is highly regarded for his papier-mâché pieces. The large mermaid stands about 15 inches tall.

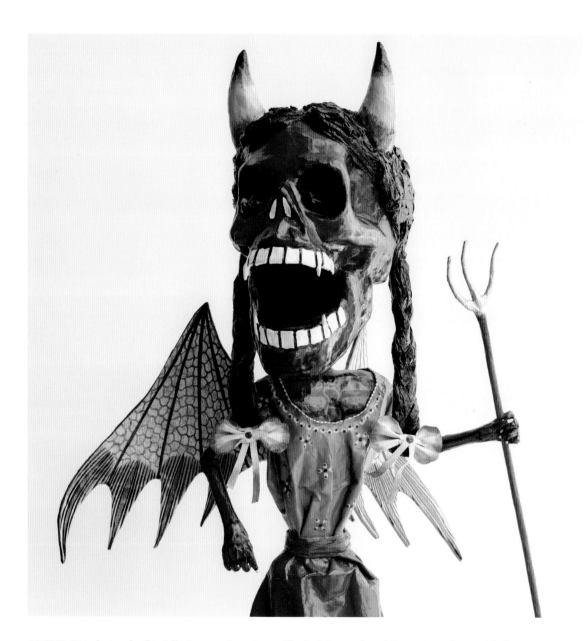

ABOVE: This daring devil is full of personality. Created by Joel Garcia from Mexico City, she is a fabulous example of the fine quality of his work. Garcia apprenticed with the late master artist Pedro Linares as a child, and has been working in papier-mâché since. Wire, newspaper, manila paper, tape, and a flour and water paste are the tools of his craft.

FACING: Joel Garcia is also known for his sense of humor. As history repeats itself, the devils and kings featured here trade places on their laps. To build a papier-mâché sculpture, Garcia first constructs a wire armature. A paste made of paper, added to the wire form, creates the volume of the figures. After they have dried thoroughly, the figures are decorated with acrylic paints.

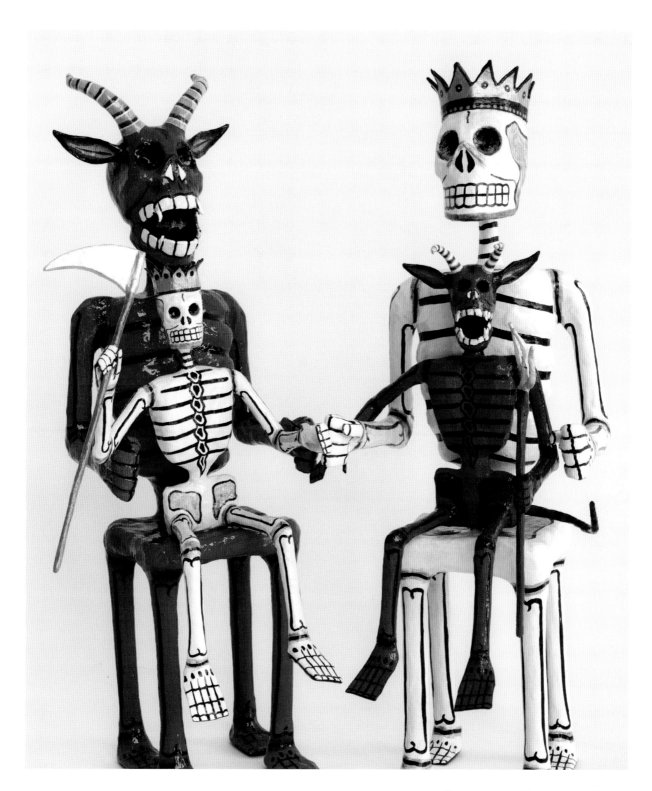

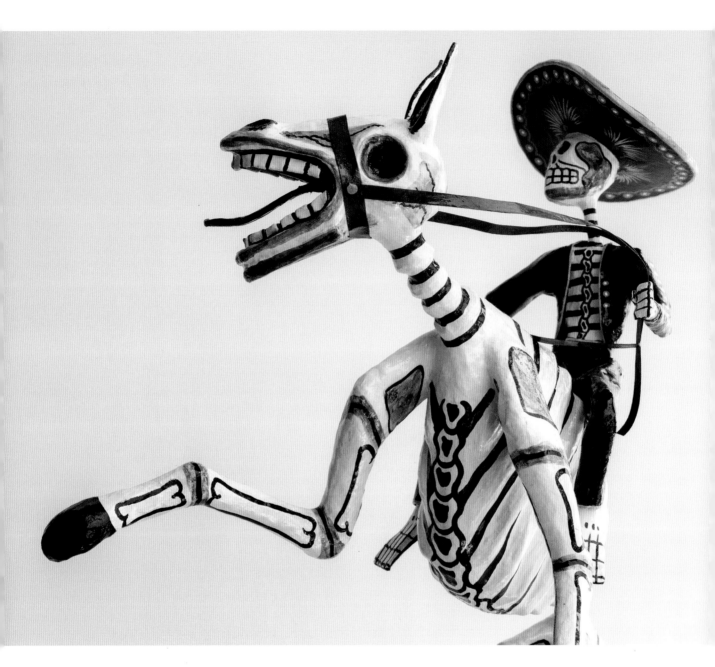

ABOVE: An experienced rider guides his rearing horse. This exquisite papier-mâché sculpture by Joel Garcia is very expressive, with strong movement suggested by the animal's rearing front legs as well as the animated faces of the horse and his rider. Both skeletal forms are beautifully delineated with black and white paint.

FACING: Joel Garcia draws much inspiration for his work from the cultural traditions of Mexico. Mariachi musicians are found in all settings, from the most remote, rural villages to the metropolitan stages of Mexico City. Dressed in a bright blue costume and dramatic sombrero, this musician plays his violin with reverence. A serape is balanced on his arm.

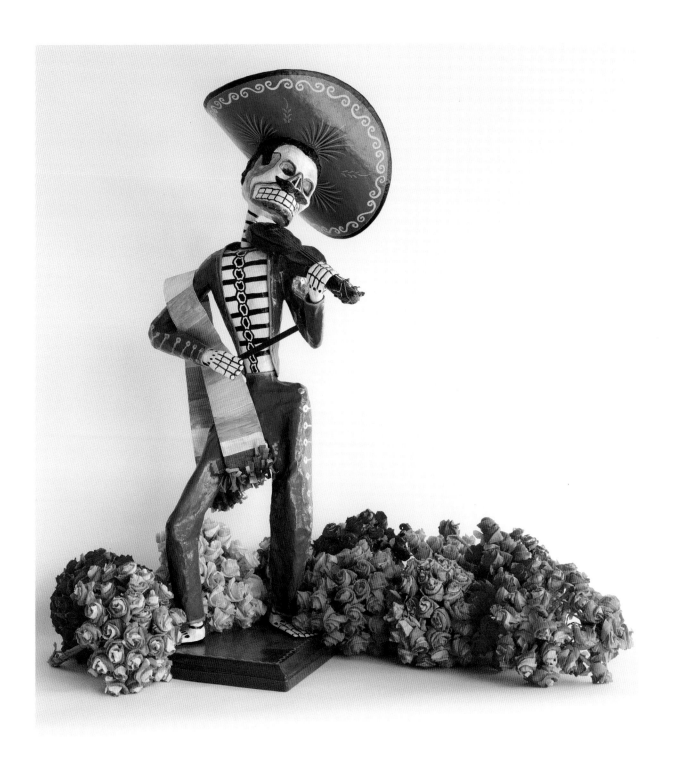

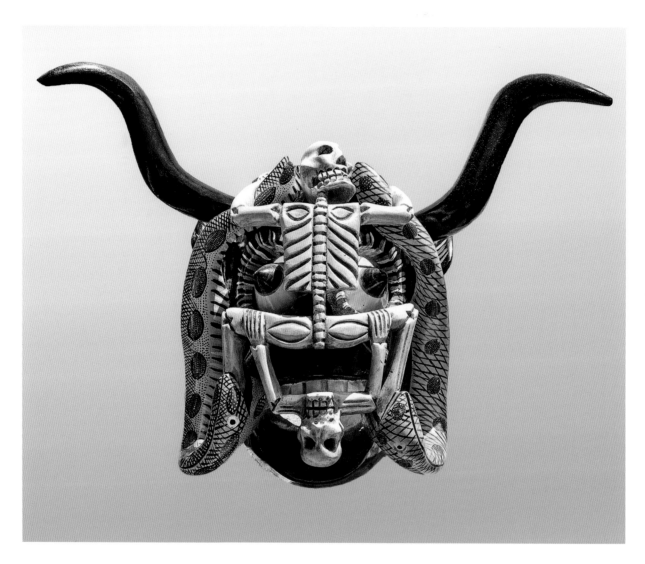

Mask-making has a long tradition in Mexico's history. The Juan Horta family, from the village of Tócuaro, Michoacán, Mexico, are renowned for their festival masks carved from wood with a machete and various knives. The fine decorations and gloss finish on their pieces are achieved with lacquer-based automobile paints. Multiple concepts often are expressed in an individual piece. In the mask featured here by Gustavo Horta, two skeletons are superimposed over a face representing a horned bovine. A pair of sinuous snakes surround the skeleton. Life size and ready to wear, this piece is a testament to the talent of the Horta family.

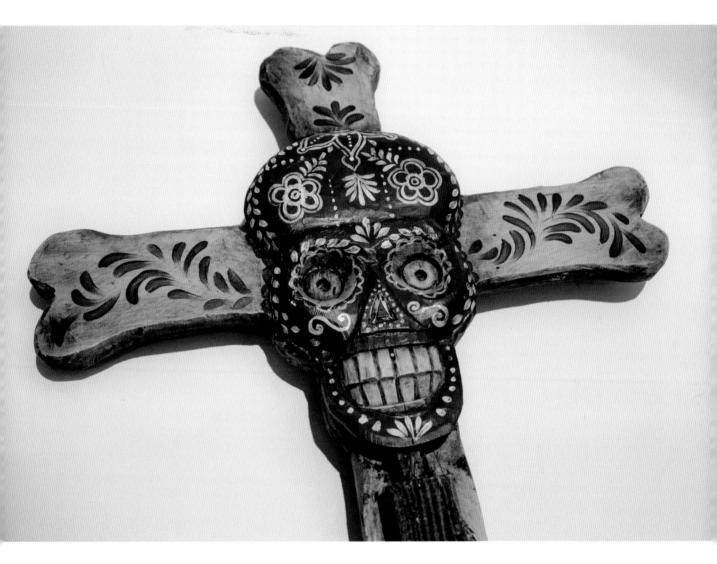

The maifestation of two divergent concepts is ever present in Day of the Dead art. Artists seek unique ways to express the cultural synthesis of the holiday. The skull is reminiscent of the Aztec culture that thrived before the arrival of the Spanish in the New World. Here, it is superimposed over the center of a cross, a symbol of Christianity brought by the Spanish. As is typical, the skull displays a happy smile to greet with acceptance the inevitable arrival of death. The deep blue paint used on the skull is decorated with white motifs. The same blue color is used to embellish the natural-toned wooden cross.

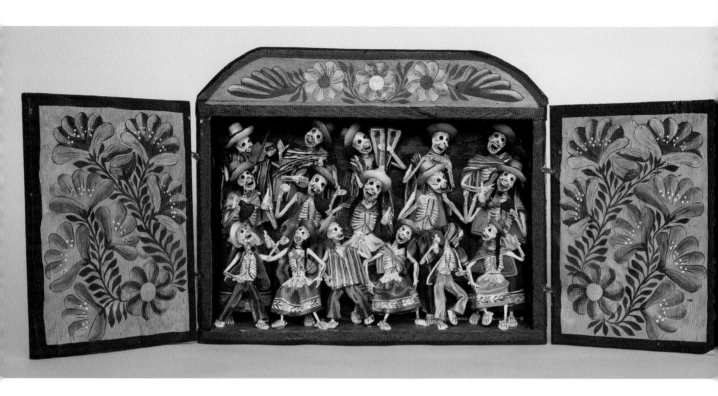

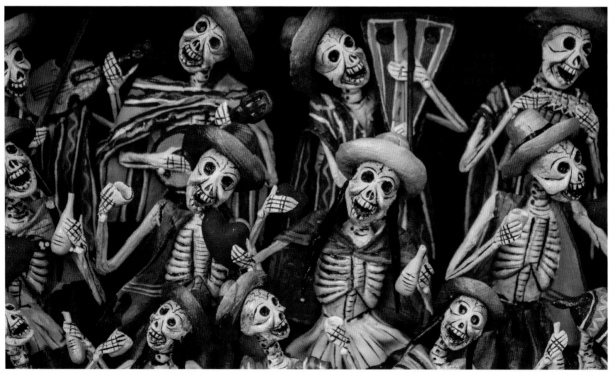

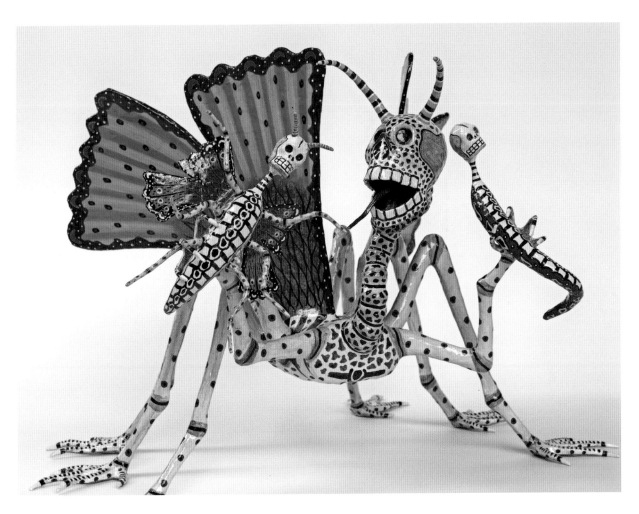

FACING: *Luis and Julia Huamani Rodriguez, from Ayacucho, Peru, create* retablos *based on the Day of the Dead theme. The handmade wooden box (top) is carved, painted, and assembled to hold the figures. It measures approximately nine by thirteen inches, excluding the doors and decorative top. Brightly colored flowers and leaf patterns are expertly painted to embellish the container. Delicate figures, about four inches in height, are sculpted from a paste of potato flour and gypsum, and depict a group of gleeful musicians and performers. A detail of the figures (bottom) reveals the skill of the artists. Each figure is fully formed in dynamic posture, and dressed in festive clothing. Bright faces express their enthusiasm and joyfulness.*

ABOVE: *Pedro Linares, from Mexico City, is considered the master sculptor of highly imaginative papier-mâché figures called* alebrijes. *Now deceased, he left a legacy of very skilled artists, like Joel Garcia, who studied with him. The insect by Garcia pictured here, a proud but watchful mother carefully guarding her two offspring from harm, is very fancifully painted with bright, arbitrary colors. The use of highly imaginative colors is a defining characteristic of an* alebrije.

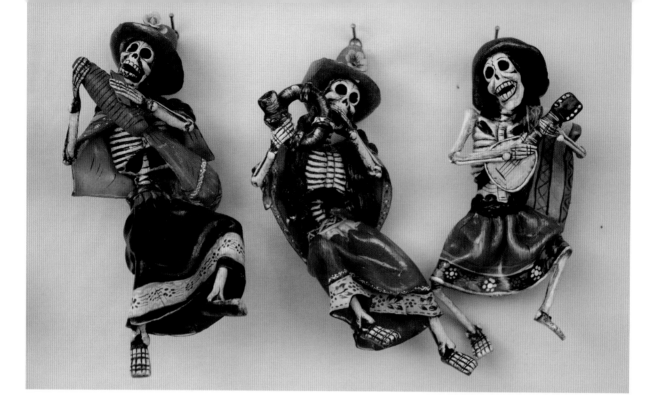

ABOVE: Three lovely musicians enjoy playing their traditional instruments for the crowd. Created by master artists Claudio Jimenez Quispe and his wife, Vicenta Flores Ataucusi, from Ayacucho, Peru, the figures are sculpted with a paste made from boiled potatoes, peaches, and agave juice mixed with gypsum. Fine cactus spines and brushes made of animal hair are used to paint the figures. With their unique, personal flair, members of the Quispe family create wonderful folk art pieces.

RIGHT: This papier-mâché figure by Joel Garcia is thoroughly enjoying his game of tennis in the afterlife. Dressed in classy tennis togs, his smile suggests a winning score.

FACING: Deceased master artist Alfonso Castillo Orta, from Izúcar de Matamoros, Puebla, has left an incredible legacy of work. This figure by Castillo represents a woman dressed for the yearly Guelaguetza, a music and dance festival held in Oaxaca, Mexico. Her village dress includes a beautiful headdress, a finely embroidered huipil, and a skirt. Lavish earrings and a necklace complete her ensemble. In her left hand, the dancer is holding a lovely bowl with a pineapple. She represents the danza piña, or the pineapple dance, from San Juan Bautista Tuxtepec, Oaxaca. Castillo's pieces are highly valued and collectible.

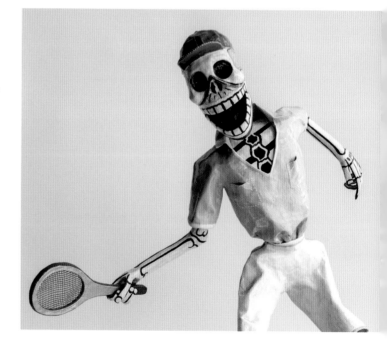

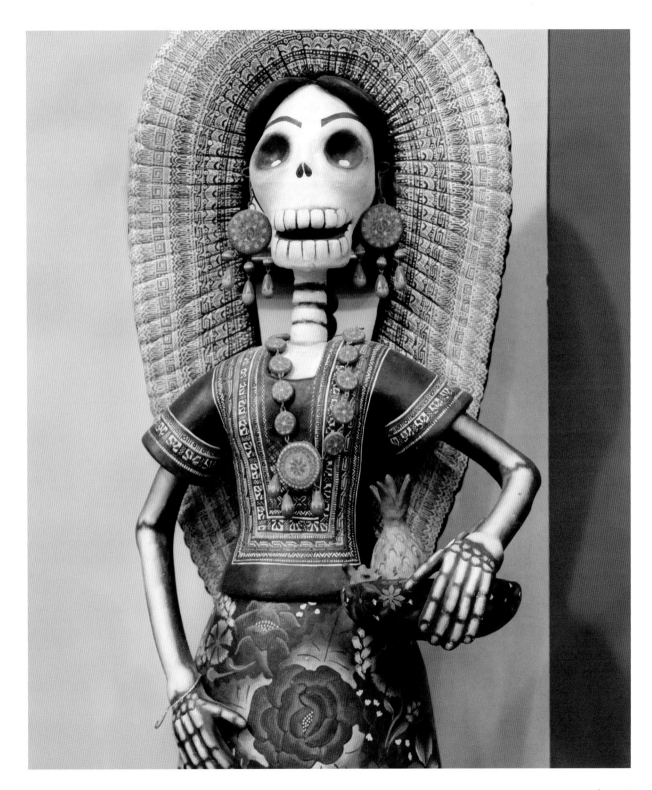

Gerado Garcia is a contemporary artist, creating innovative pieces inspired by the time-honored pottery tradition of talavera. *The process of creating* talavera, *a maiolica pottery, was brought to the New World by the Spanish in the sixteenth century. It is produced exclusively in Puebla and a few surrounding cities. An inquisitive puppy, pictured above, is glazed white with black details except for his cap, which mirrors the colors and designs of* talavera *pottery. The sculpture is seven by ten by four inches.*

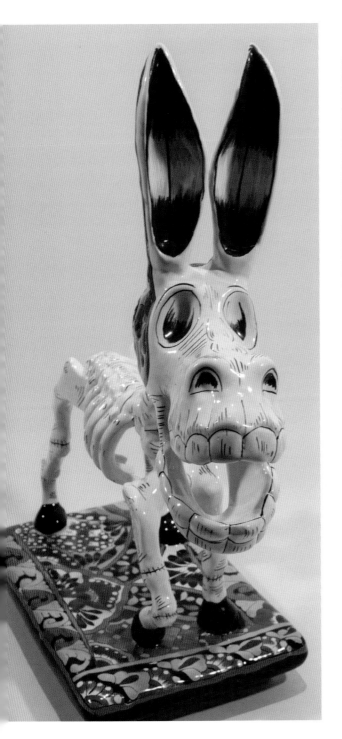

LEFT: A whimsical donkey smiles at onlookers, standing sixteen inches high on a base decorated with talavera-inspired designs. The rich colors offer a pleasing contrast to the white-glazed body. His large black ears add to the humorous quality of the piece. Gerado Garcia's pieces embody a strong sense of whimsy.

ABOVE: Similar in design to many Day of the Dead skulls, Gerado Garcia's white skull is embellished with insects and butterflies. The vibrant orange, yellow, blue, and green colors used on the head offer a strikingly beautiful accent. Black details emphasize the large eyes, teeth, and open mouth.

RESOURCES

Bazaar del Mundo
4133 Taylor Street
San Diego, CA 92110
619-296-3161
www.bazaardelmundo.com
Folk art, crafts, jewelry, fashions and accessories, textiles, kitchen and dining ware, books

Casa Artelexia
2400 Kettner Blvd. #102
San Diego, CA 92101
619-544-1011
www.artelexia.com
Folk art, books, jewelry, paper flowers, *papel picado,* furnishings, accessories

CRIZMAC Art and Cultural Travel
2981 N. Santa Rosa Place
Tucson, AZ 85712
520-323-8555
www.crizmac.com
Day of the Dead art tours to Mexico, books

The Folk Tree
217 South Fair Oaks Ave.
Pasadena, CA 91105
626-795-8733
www.folktree.com
Folk art, books, jewelry, paper flowers, *papel picado,* accessories

MexicanSugarSkull.com
4920 Pinecroft Way
Santa Rosa, CA 95404
707-537-9787
www.MexicanSugarSkull.com
Sugar skull molds and supplies, folk art, *papel picado,* restaurant supplies, gifts

Stevie Mack (left) is a nationally known art educator, curriculum developer, and tour guide. **Kitty Williams** (right) has long had a passion for Mexican art and culture. Ms. Mack has been leading educational tours to national and international sites for over twenty years, and along with Ms. Williams, has led numerous tours to Mexico for Day of the Dead festivities. Considered leading authorities on the topic, the two previously collaborated on the book *Day of the Dead* (Gibbs Smith, 2011). Both authors live in Tucson, Arizona.

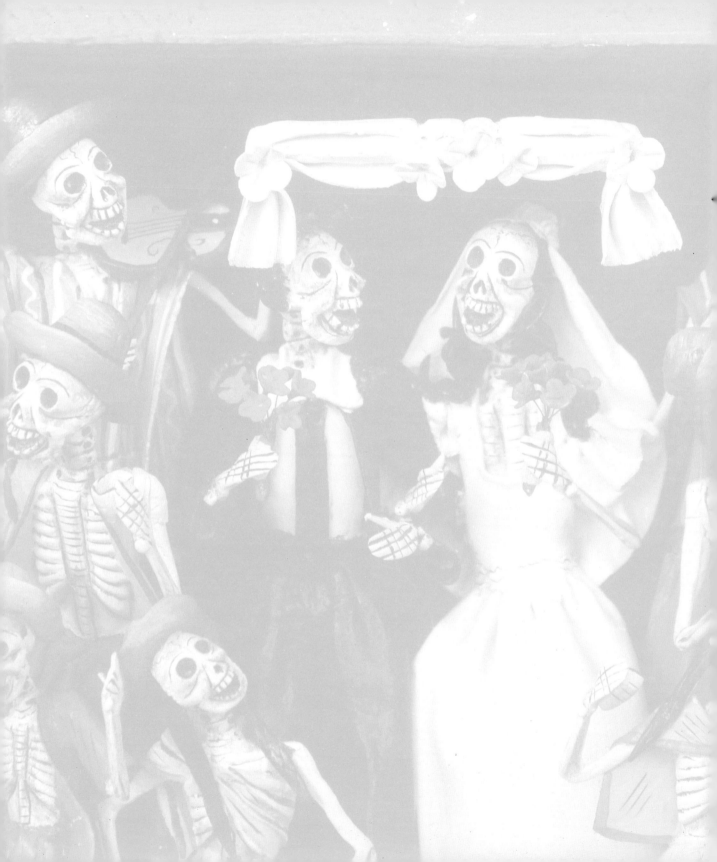

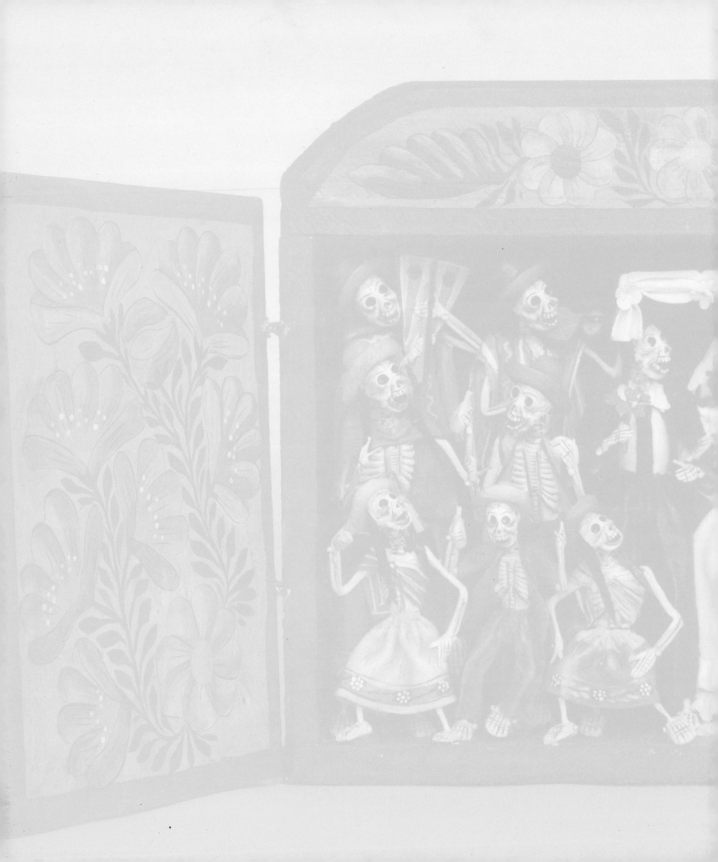